Hinkas Through the Ages

Karen Roop

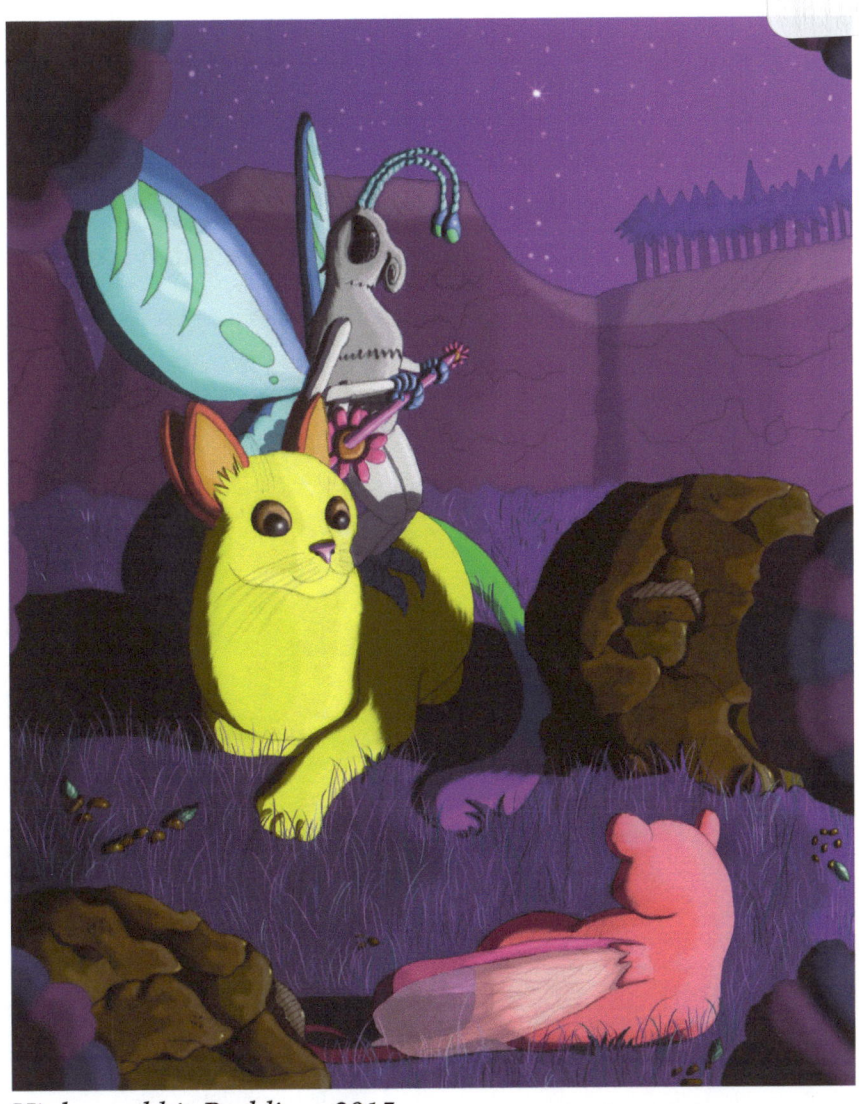

Hinka and his Buddies - 2015

Acknowledgments & Copyright

I would like to thank my sister and fellow artist, Cathy Roop, for being a great comrade and supporter in the creation of this book and throughout my artistic life.

I would also like to thank my parents for supporting me my entire life and encouraging me to continue developing my artistic talent.

For my brothers, who have also supported me over the years.

And to everyone else who has liked or bought my artwork, encouraging me to create even more.

••

Copyright © 2017 by Karen Roop. All rights reserved.

No part of this book may be reproduced in any form or by any electronic or mechanical means including information storage and retrieval systems without permission in writing from the author.

All artwork was created by Karen Roop. This book was designed with InDesign CS6 by Karen Roop. The letters for the title were developed by Karen Roop.

This is a product of Aliens of Lactopia, Karen Roop's artwork brand. Visit www.aliensoflactopia.com to learn more.

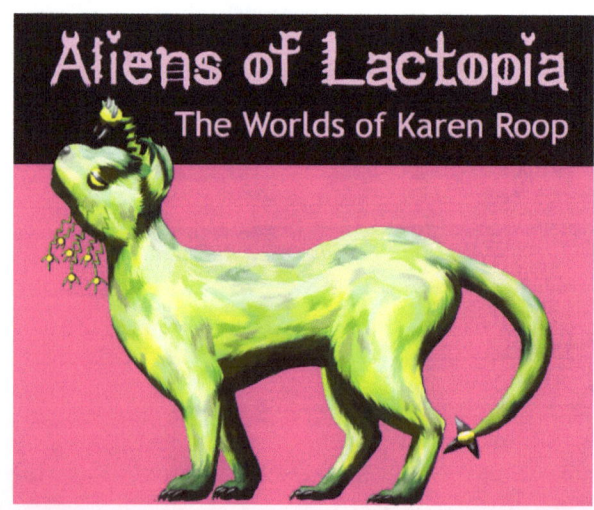

Table of Contents

Introduction... 4
In the introduction I explain what Hinkas are, discuss the tools I use to create artwork, and give an overview of the artwork in the book.

Chapter One: Cats.. 6
Cats are the type of animal I drew most as a kid. This chapter gives an overview of the most common cat-like hinkas.

Chapter Two: Rodents..................................... 22
This chapter represents some mice-like hinkas along with some other rodents.

Chapter Three: Reptiles.................................. 38
Dragons were the reptile I liked the most as a kid. This chapter shows the most common dragon hinkas and other hinka reptiles.

Chapter Four: Other Hinkas............................ 50
Other hinkas are those which don't fit into any of the other chapters, such as insects, horses, and birds.

Conclusion... 66
Index... 68
About the Artist.. 70

Introduction

What Are Hinkas?

Hinkas are a group of creatures inspired by Pokemon that I developed as a child. They reside on an imaginary planet that was originally named Poiuyt (pronounced as "pout"). Some hinkas resemble real-life animals and others do not.

The drawing below shows what I thought of hinkas as a kid: "**HINKA was founded by KAREN ROOP and hinkas are very creative creatures. There are over 200!! Made by Karen Roop alone.**" The ones in this picture were hinkas I drew many times as a child, but I have not redrawn all of them as an adult (yet).

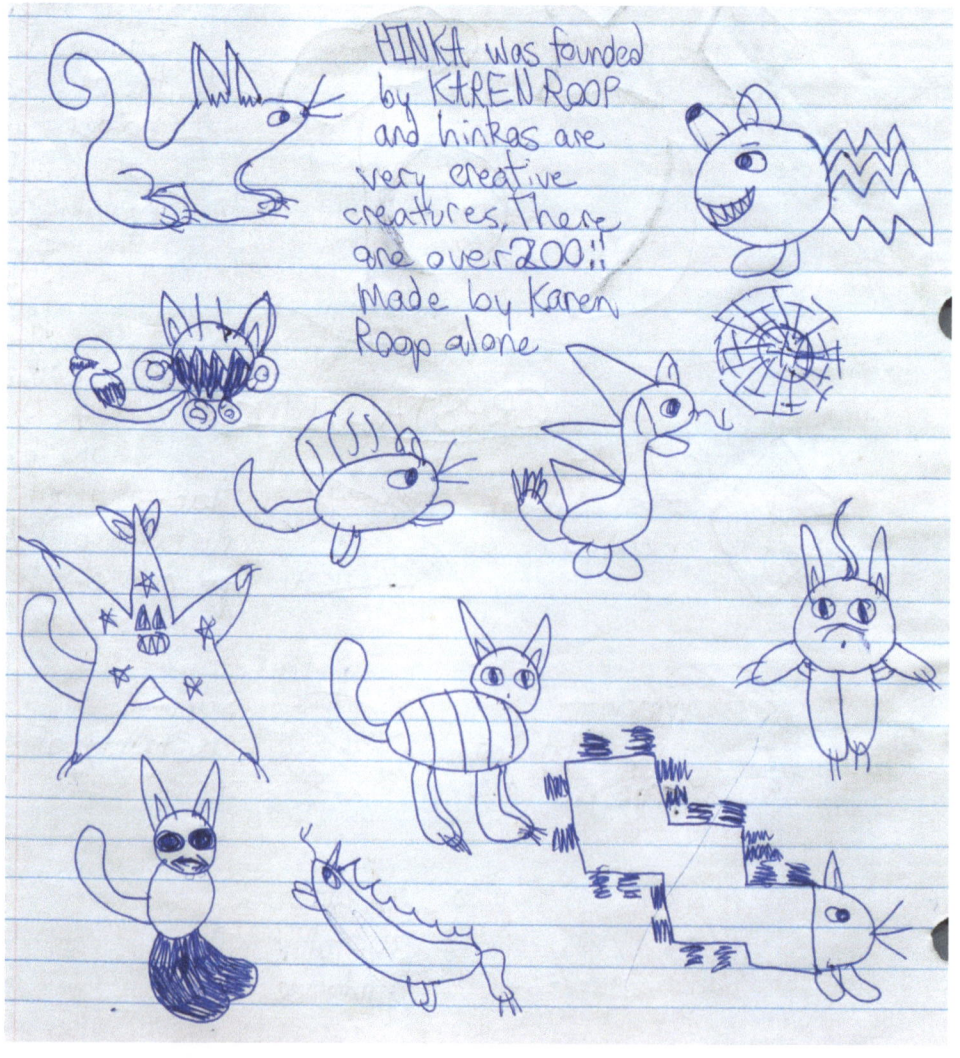

Introduction

Artist Tools

The artwork I did as a child was usually drawn on paper using pen or pencil. I also made some drawings using colored pencils and other media.

Later in life I started creating digital art. Some of the artwork was drawn on paper then scanned and digitally colored or was created entirely on a computer. The tools I've been using lately to create digital art are Manga Studio 5, Photoshop CS6, and a Wacom Intuos Pro Tablet.

About the Artwork

All of the hinkas featured in this book are those which I redrew over the years. Some of them I redrew in both high school and in adulthood and others I only redrew once in adulthood.

The artwork featured in this book is divided into three sections:
- Childhood (1998 - early 2004)
- High school (late 2004 - early 2008)
- Adulthood (late 2008 - mid 2017)

Example Childhood *Example High School* *Example Adulthood*

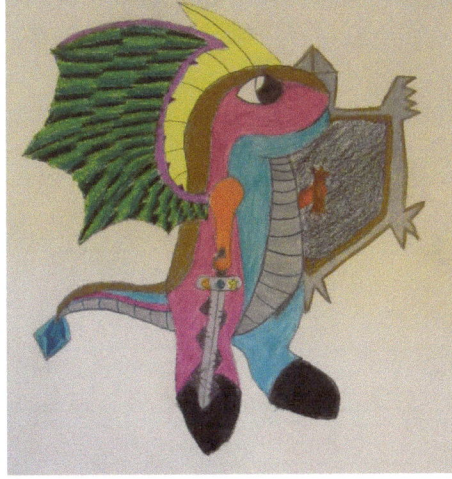
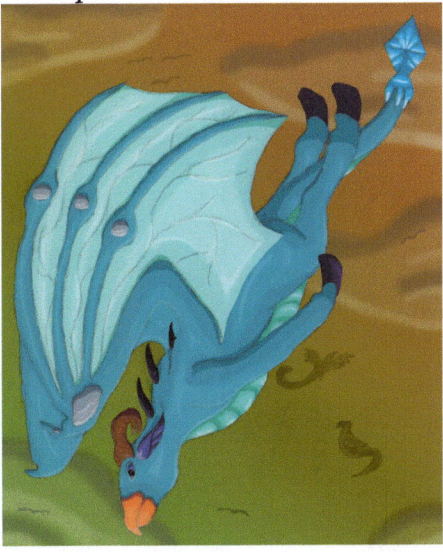

There is one section—Hinka the Rainbow Cat (see p. 8)—that also includes artwork I completed prior to 1998.

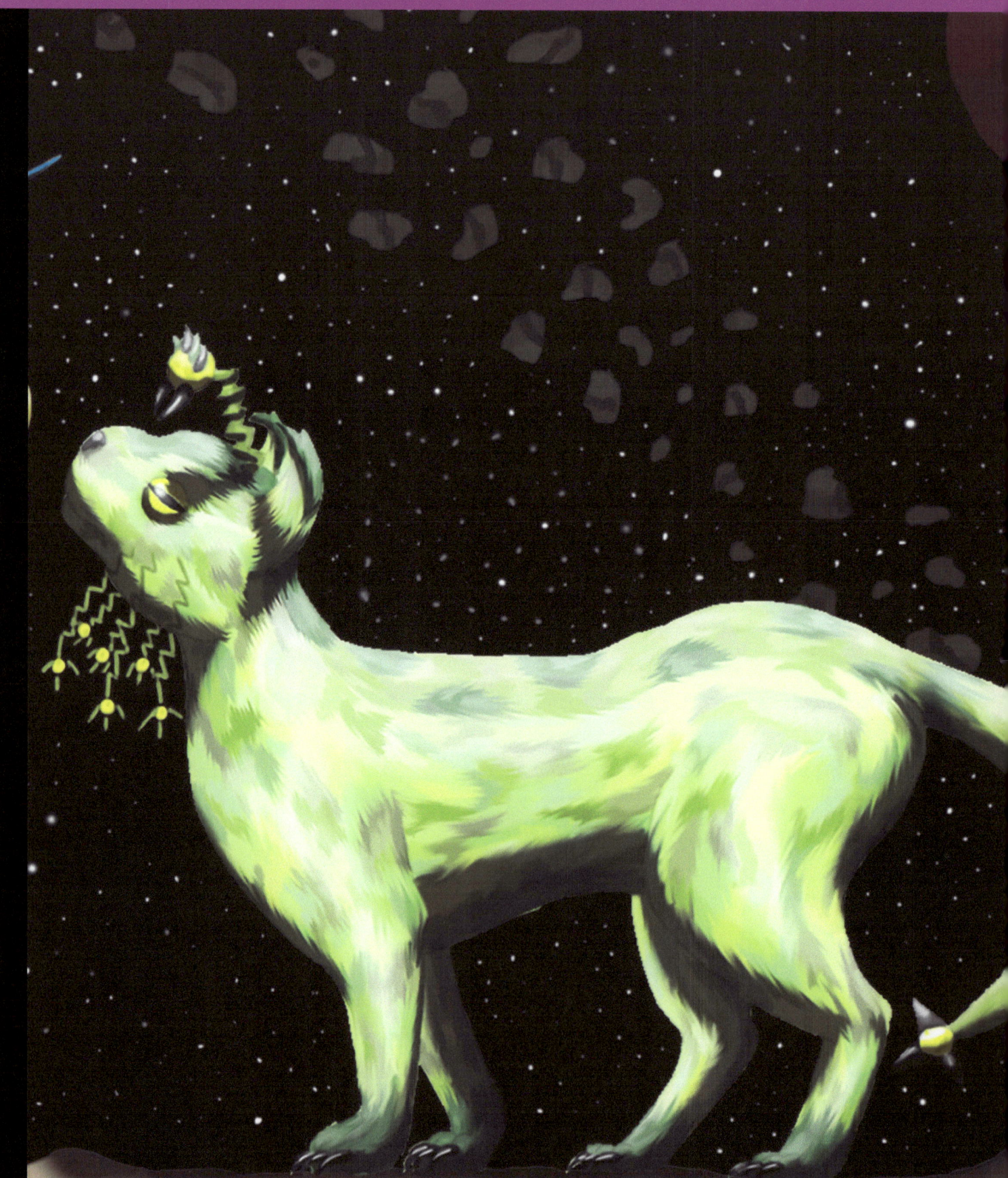

Chapter 1: Cats

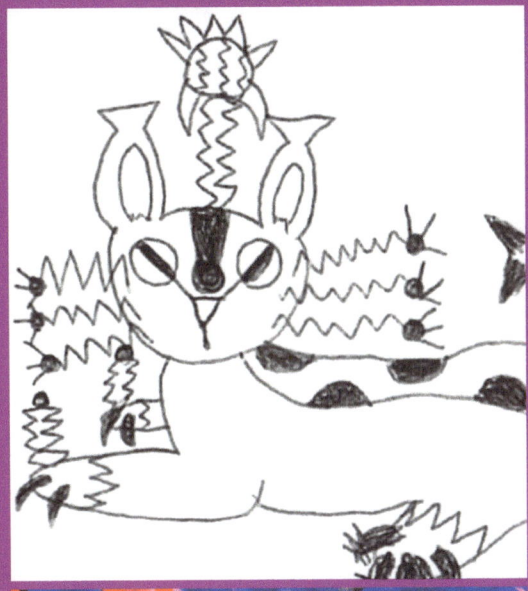

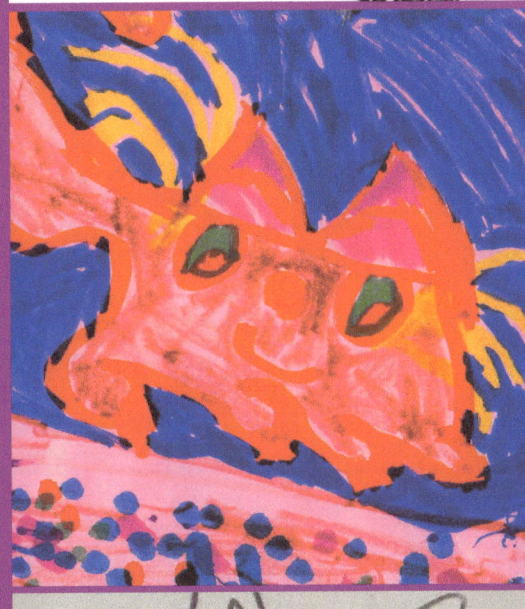

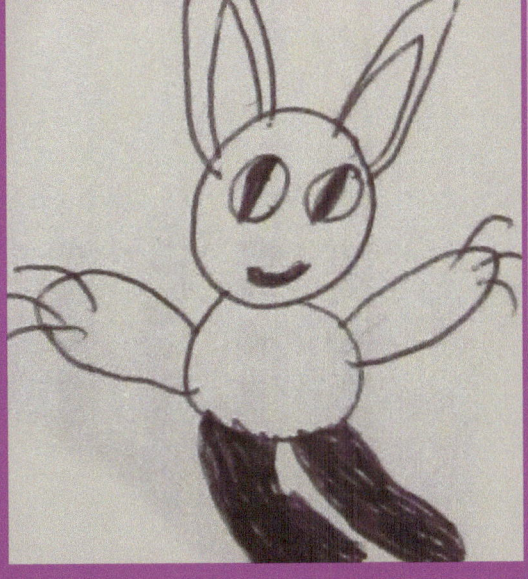

Cats were my favorite animals as a kid. I remember I really, really wanted one and bought all kinds of cat books. One day, my family rescued a stray cat and we decided to keep her. I finally got my kitty!

My cat, whom we creatively named "Gata," is now spoiled rotten (see p. 70 for a drawing):

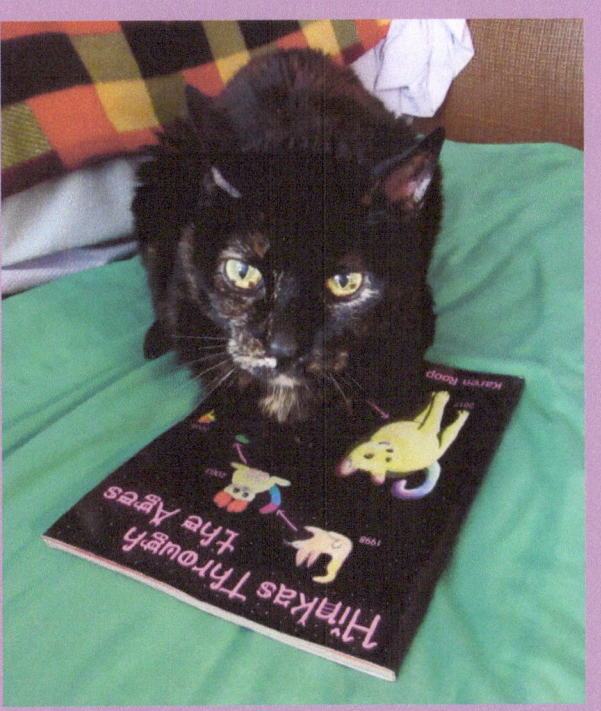

I drew many variations of cats as a kid. I haven't drawn them as much as an adult but I still like to draw them. It's fun seeing my super old drawings being transformed into more realistic versions over the years.

Cat Hinka 1: Hinka the Rainbow Cat

Hinka, with a capital H, was a character I developed as a kid (not to be confused with "hinkas" which refer to all of my childhood made-up creatures). He is a rainbow-colored cat with four ears who is excited by everything and everyone. He is best friends with Crystal the crystal butterfly (see p. 52). Hinka is one of my hinka characters I've drawn the most throughout my life. I mostly drew Hinka when I was a child, but I did draw Hinka a bit when I was older.

Early Childhood Versions

These cats were drawn before I invented Hinka back in 1998. I didn't know any proper English back then. I also had absolutely no concept of cat anatomy.

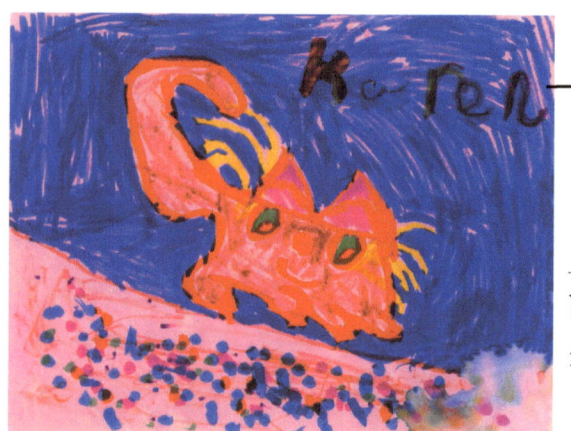

A rare full-colored version of a kitty. The red stands out really nicely against the blue background!

A cat catching a bird. One of my first action pictures.

This is a box-like cat. The top letters apparently stand for "Christmas" and the bottom for "Kitty Kat."

Childhood Versions

"Hinka" was originally a species. These are some of the individuals in this "species." It's just a normal cat.

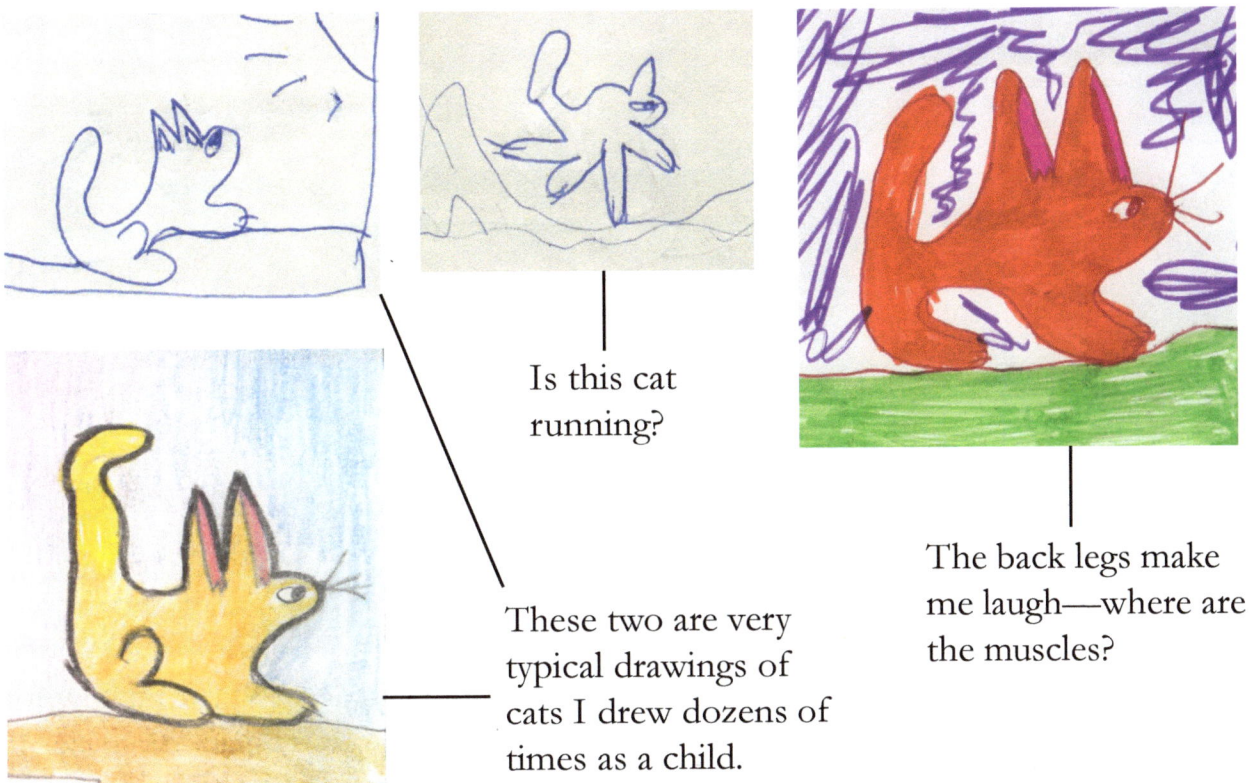

Is this cat running?

These two are very typical drawings of cats I drew dozens of times as a child.

The back legs make me laugh—where are the muscles?

· ·

This is when I introduced "four-eared" cats. I realized that the cats in the above drawings look like they have two pairs of ears, and not just one, so I adjusted them in future drawings.

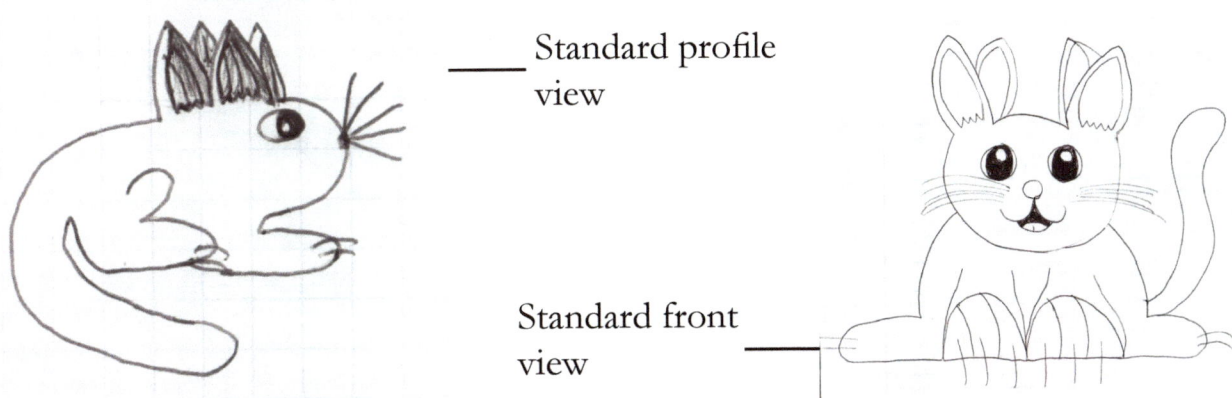

Standard profile view

Standard front view

Eventually I established the colors for the character "Hinka" instead of having this four-eared cat design as just a species. Starting at this point, Hinka, the character, was always drawn as a rainbow-colored four-eared cat.

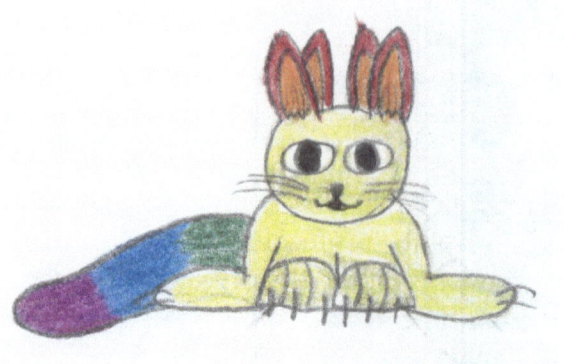

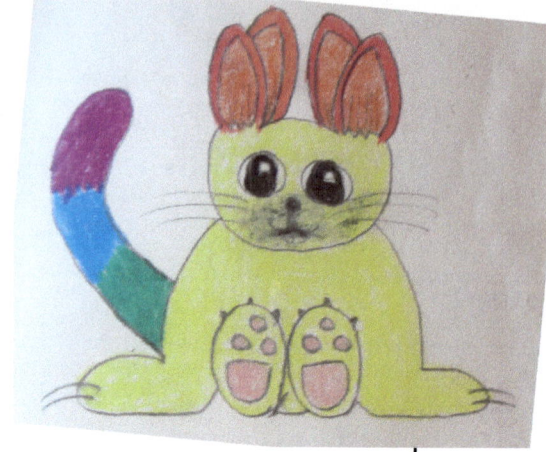

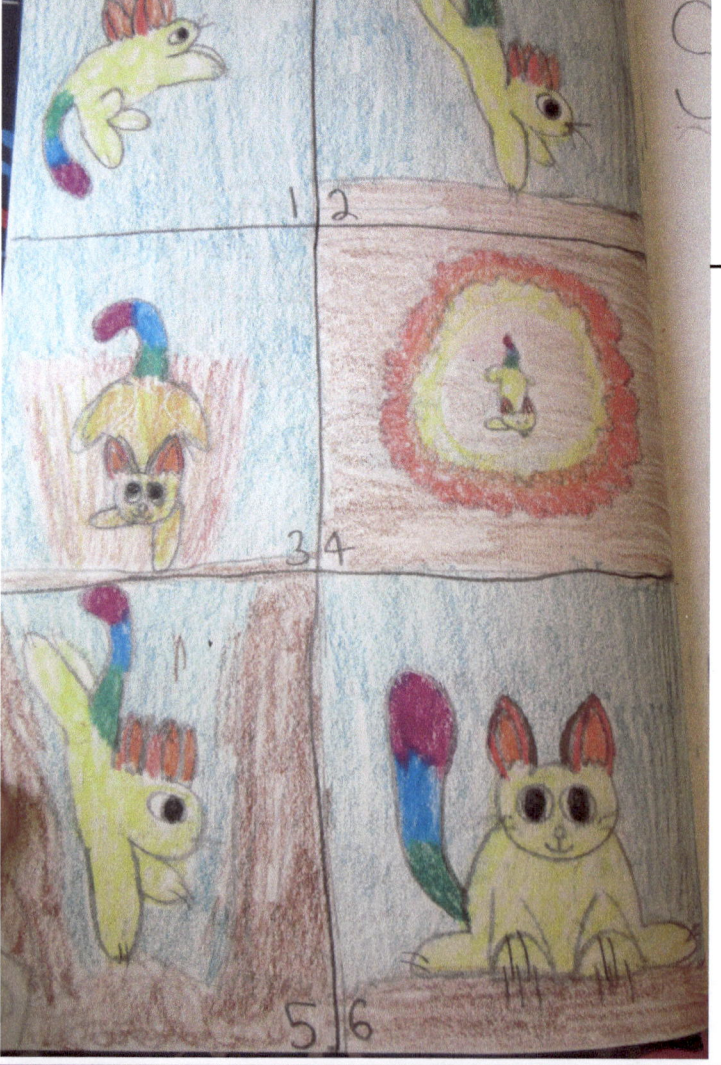

Standard sitting front view

The "cute" sitting pose.

Steps for Hinka's special "Friction Fire" attack. See card below for details (I created a lot of these "battle" or "info" cards as a kid).

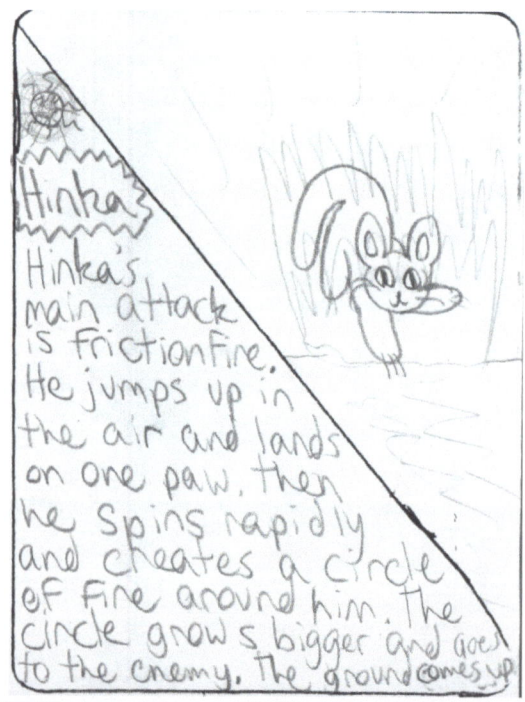

High School Versions

These are examples of Hinka I drew in high school. I started trying out different poses with different perspectives (three-quarters, bird's eye view, etc.)

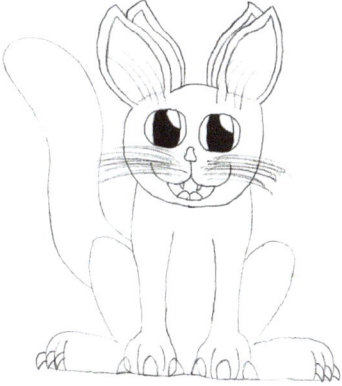

A standard front view. I added claws that weren't just lines and more muscles to the legs. I also tried to make the ears a little more interesting.

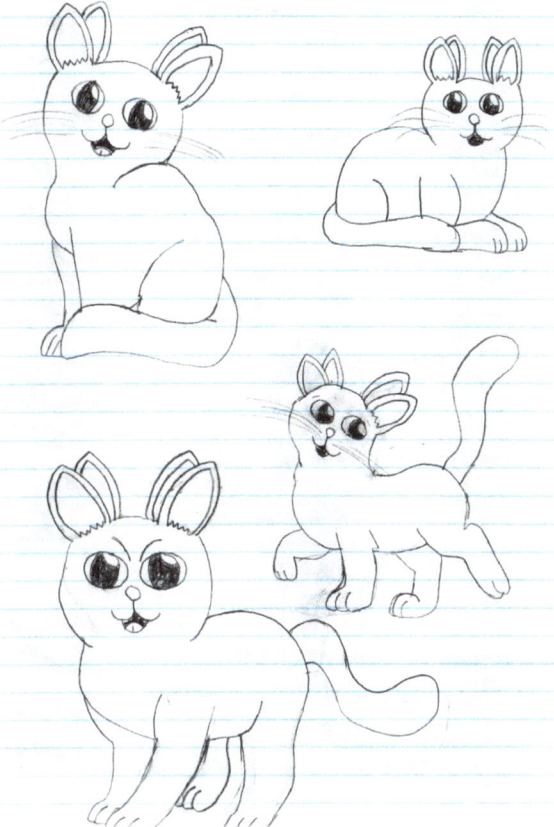

A variety of poses for Hinka. Some of them were inspired by Lisa Frank cats. I was starting to get a better handle of cat anatomy at this point.

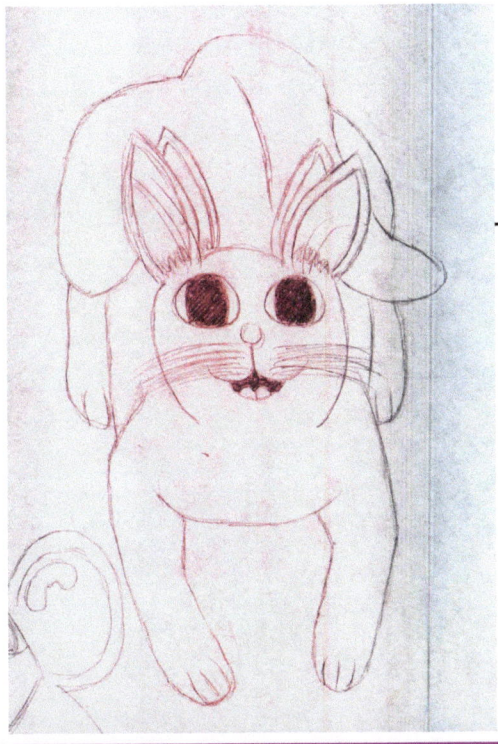

A view from above. I very rarely draw anything this from perspective.

A colored version done in Photoshop.

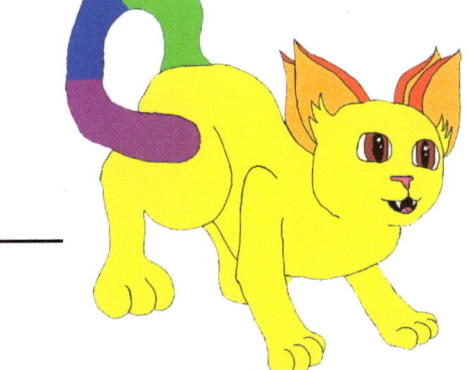

Hinkas Through the Ages

Adulthood Versions

I drew a few variations of Hinka as an adult. I've gotten a much better handle on cat anatomy, especially in the past couple of years.

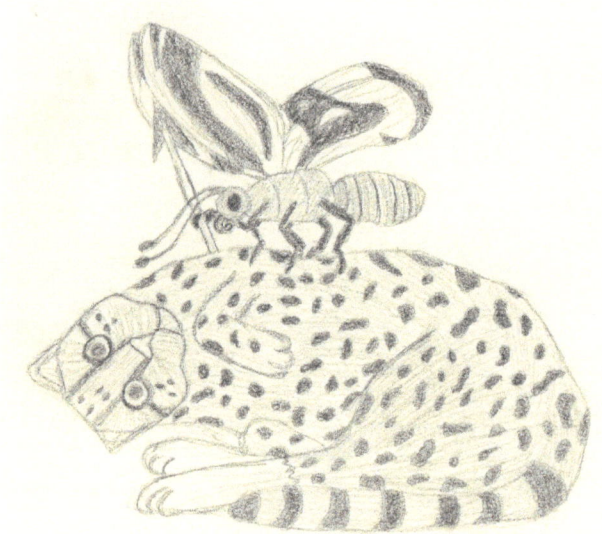

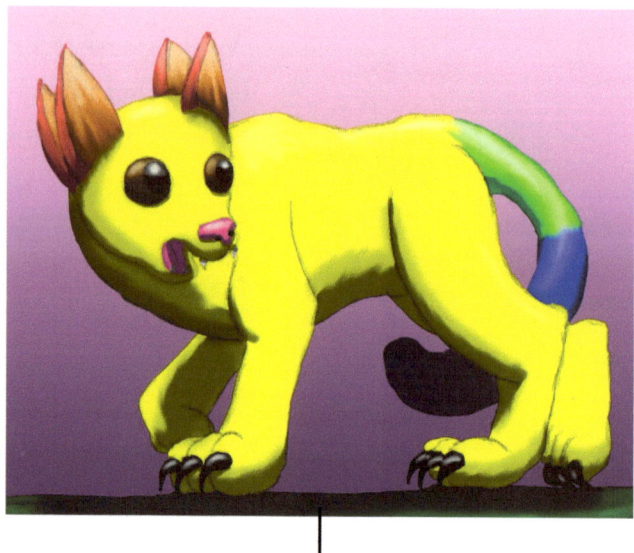

This is Hinka as some sort of wild cat (a type of design I was experimenting with for a while). His friend, Crystal (see p. 53), is on top of him.

This is a drawing of Hinka I drew in 2015. It was for a comic about Poiuyt (pronounced as pout) which I never finished.

This is from "Hinka and his Buddies" (see title page). He's hanging out with his friend Crystal (p. 54) and a kikacoon (p. 28).

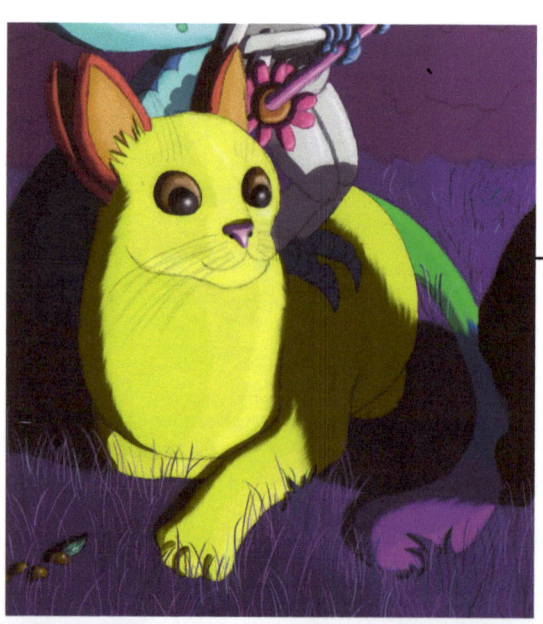

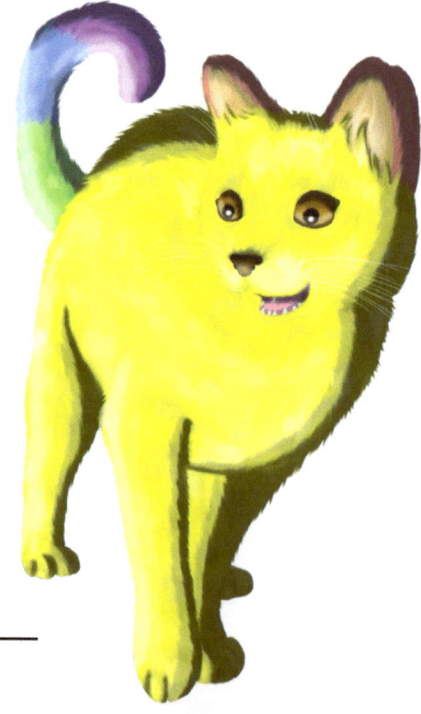

Since the left picture was done in 2015, I drew this version for this book to represent my most recent style.

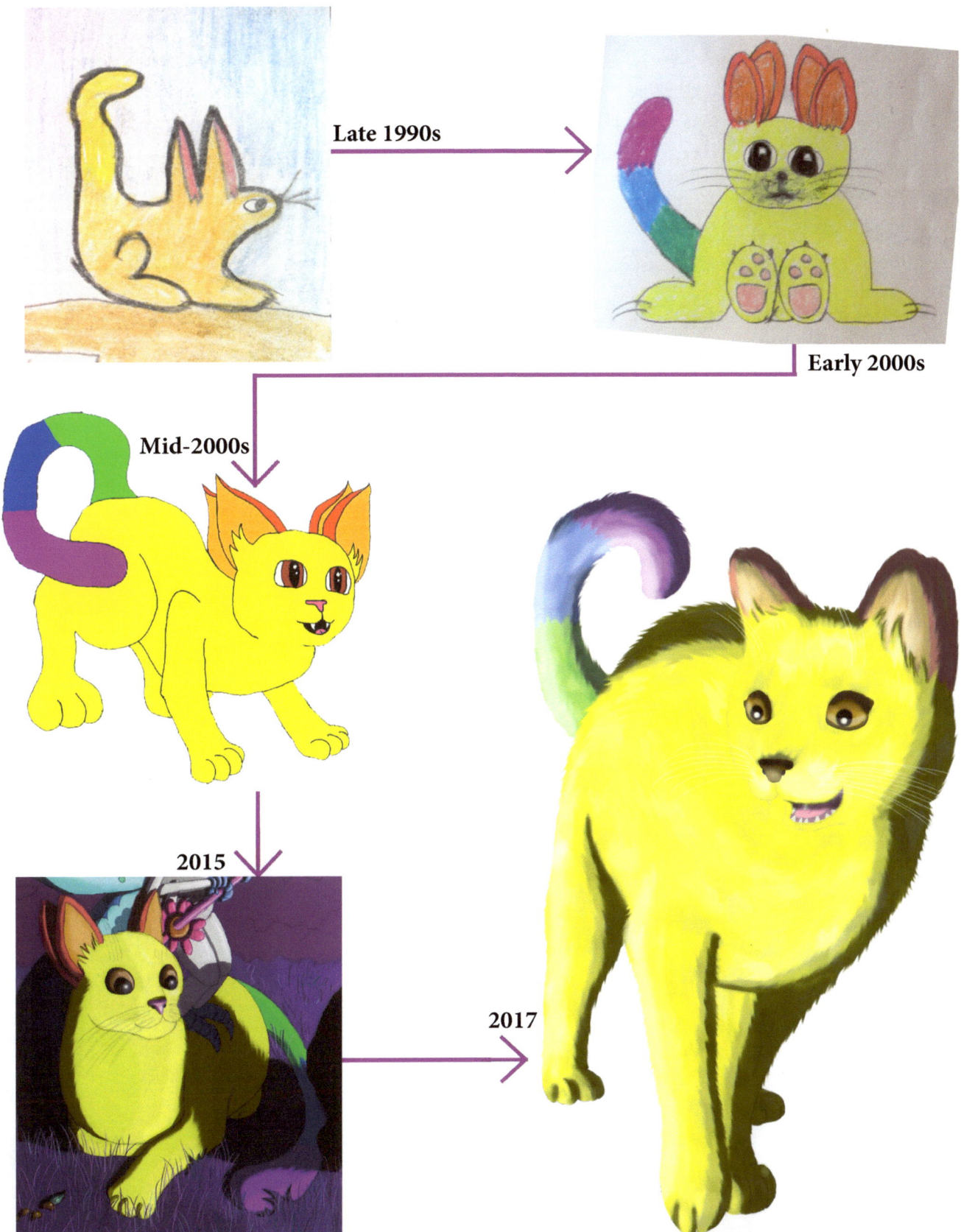

Hinkas Through the Ages

Cat Hinka 2: Creainka

Creainka (cree-uh-INK-uh) was a species that I didn't draw too much when I was younger. I really liked the design, but I focused more on drawing different cat hinkas as a kid. I'm not sure what the horns on the head were intended for. They were probably added because they look really cool. Later on I decided it would be great if they actually had magical abilities.

Childhood Versions

Creainka is a cat hinka defined by its large whiskers and forked horns on its face. A lot of the time I drew this creature with crossed eyes.

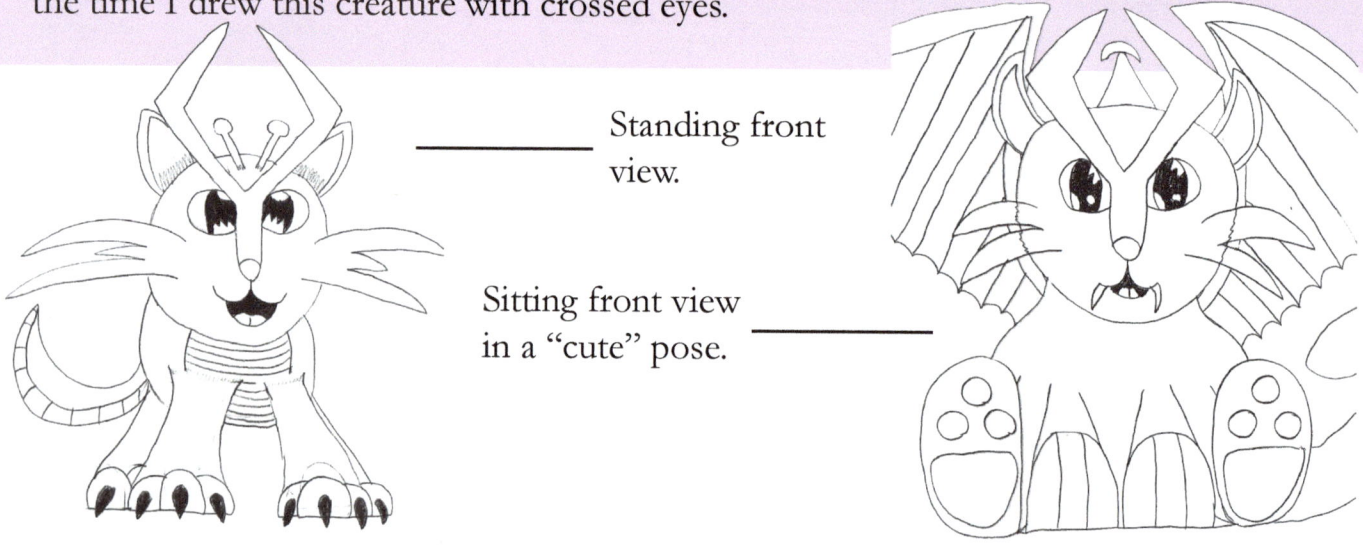

Standing front view.

Sitting front view in a "cute" pose.

Adulthood Versions

I didn't draw Creainka again until I was in college. These are a few pictures from a comic intended for web I drew with a Creainka character (named "Creainka"—so creative!).

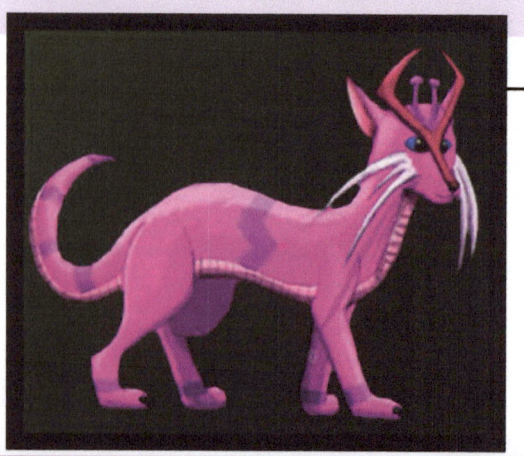

Standard profile view

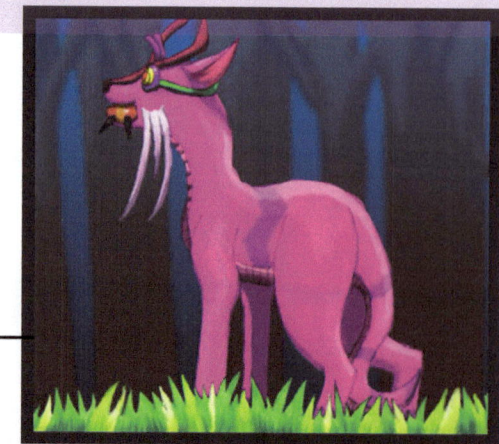

Creainka wearing goggles called "Phyzix (fye-zicks) glasses"—a specialty hinka item.

Creainka wearing "Eaglipsies (ee-glip-seas) Wings." These are devices a hinka without wings straps on to fly!

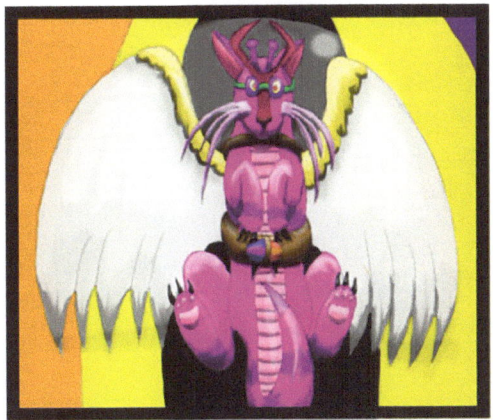

Creainka flying up to save the other protagonist of the comic, Kikacoon (see p. 29).

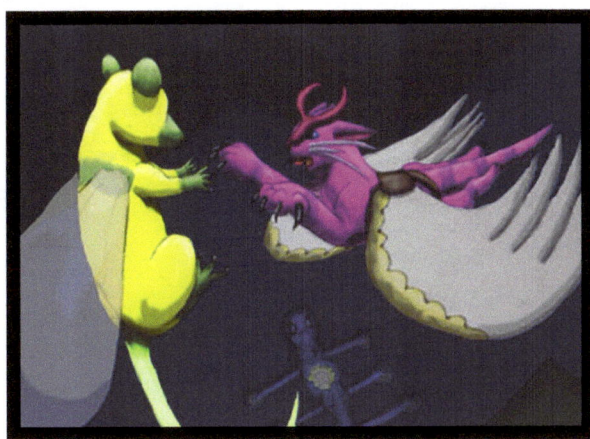

Creainka with Kikacoon (see p. 29) going on an adventure!

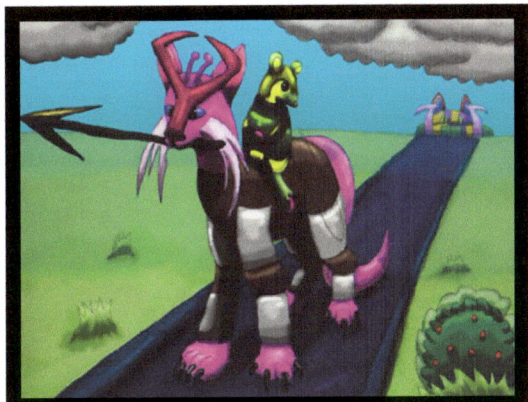

This picture below has a kikacoon on the left (see p. 24), a creainka in the middle, and a snakia on the right (see p. 49).

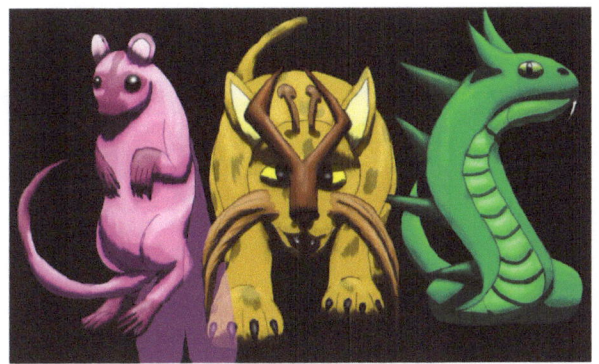

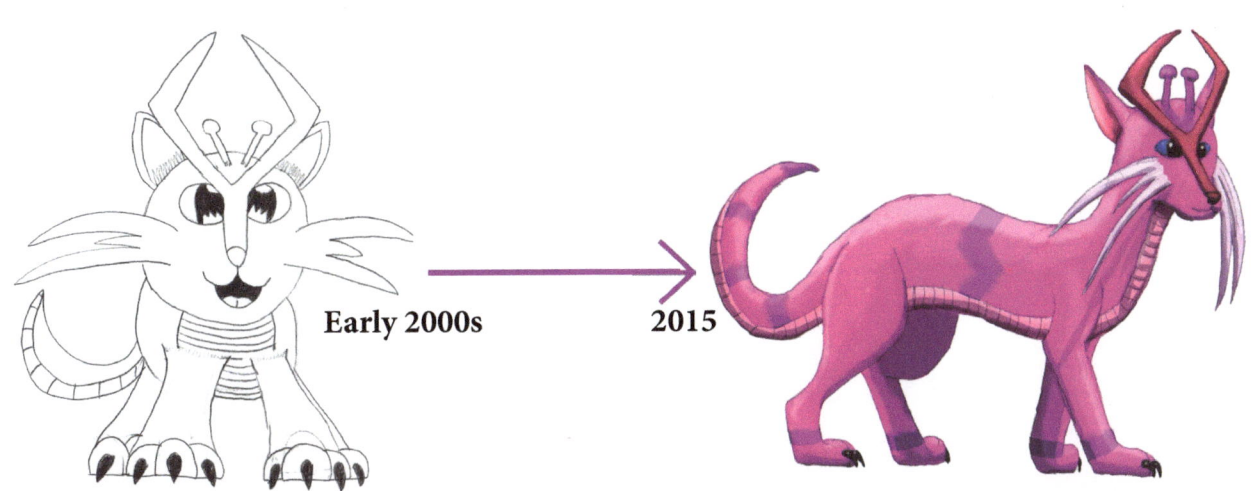

Early 2000s → 2015

Hinkas Through the Ages

Cat Hinka 3: Wave Creainka

The wave creainka (cree-uh-INK-uh) is a "wavy" form of the normal Creainka. It looks like an electrified cat to me.

I love the design of this hinka which I why I chose it for one of my more recent hinka designs. The wavy whiskers and designs aren't as prominent in the 2017 design, but I still like the way it turned out.

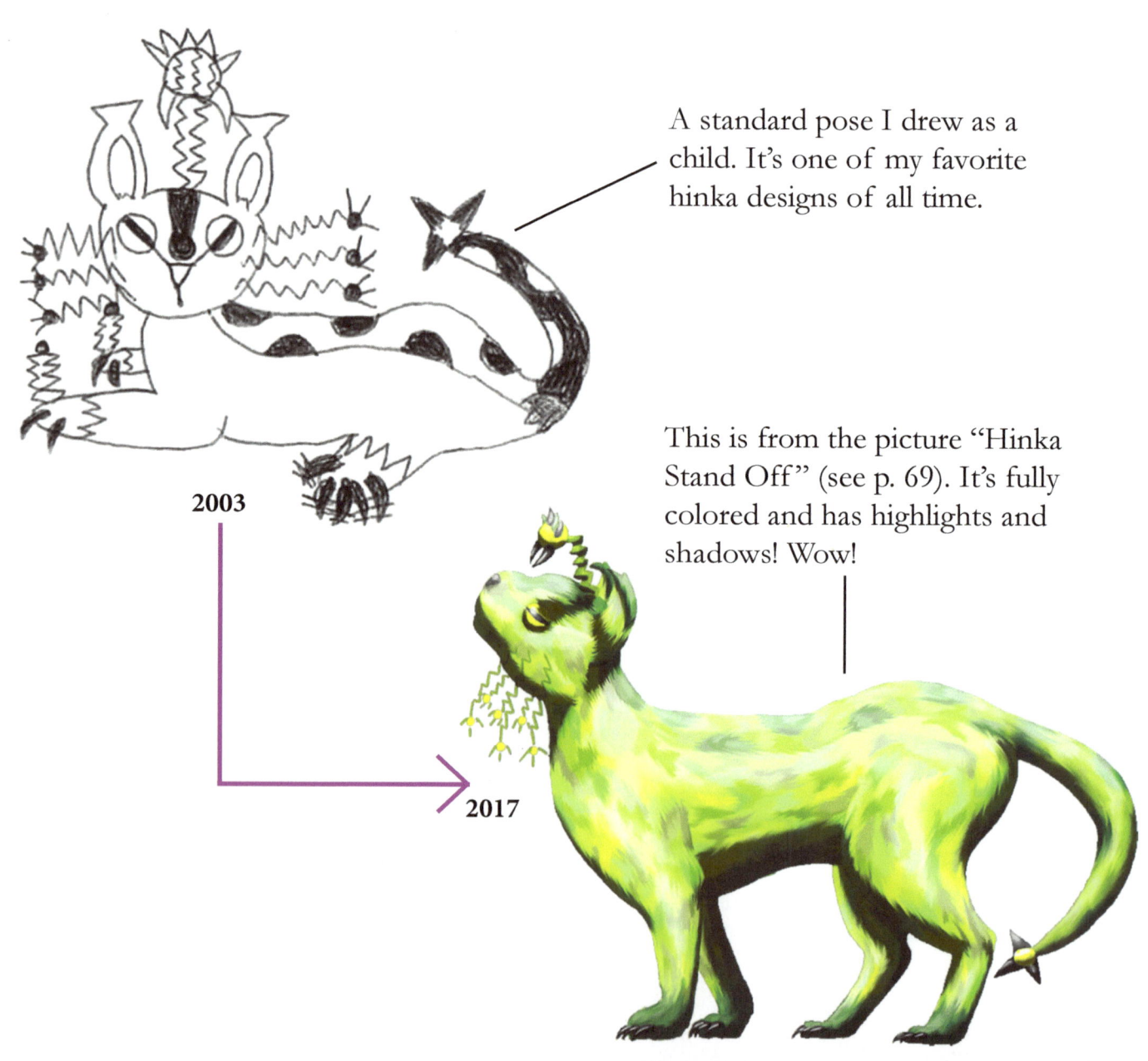

2003

A standard pose I drew as a child. It's one of my favorite hinka designs of all time.

2017

This is from the picture "Hinka Stand Off" (see p. 69). It's fully colored and has highlights and shadows! Wow!

Cat Hinka 4: Repapkoobeton

Repapkoobeton (reh-pap-KOO-beh-tahn), or Repap, is the "creator" of Poiuyt (pronounced as pout). I first drew it back in 2004 and gave the character the name "Repapkoobeton" because that is "notebook paper" spelled backwards (and it was originally drawn on notebook paper). I drew this character a few more times, with a couple changes in high school and more drastic changes in college.

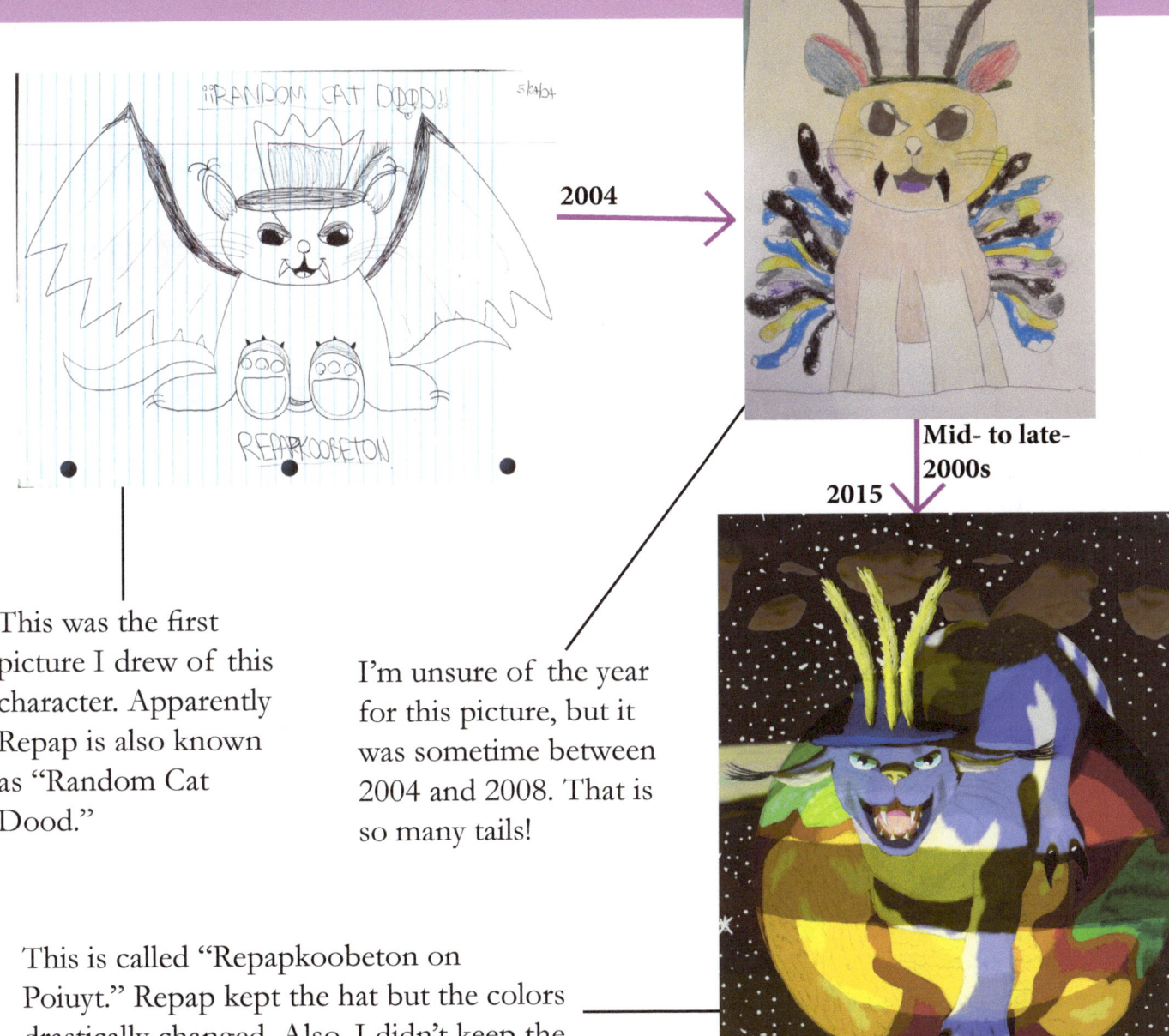

2004

Mid- to late-2000s

2015

This was the first picture I drew of this character. Apparently Repap is also known as "Random Cat Dood."

I'm unsure of the year for this picture, but it was sometime between 2004 and 2008. That is so many tails!

This is called "Repapkoobeton on Poiuyt." Repap kept the hat but the colors drastically changed. Also, I didn't keep the dozens of tails.

Hinkas Through the Ages

Cat Hinka 5: Heneka

Heneka (hen-eh-kuh) is a hinka I drew many times as a child but didn't draw again until much later in life. It's distinguished by its large legs and having no arms. The mouth is also in a weird double-arrow shape and I'm not sure why I loved that so much as a kid.

Although it doesn't really look like a cat, it has the standard cat ears and cat tail so I just threw it into the "cats" category.

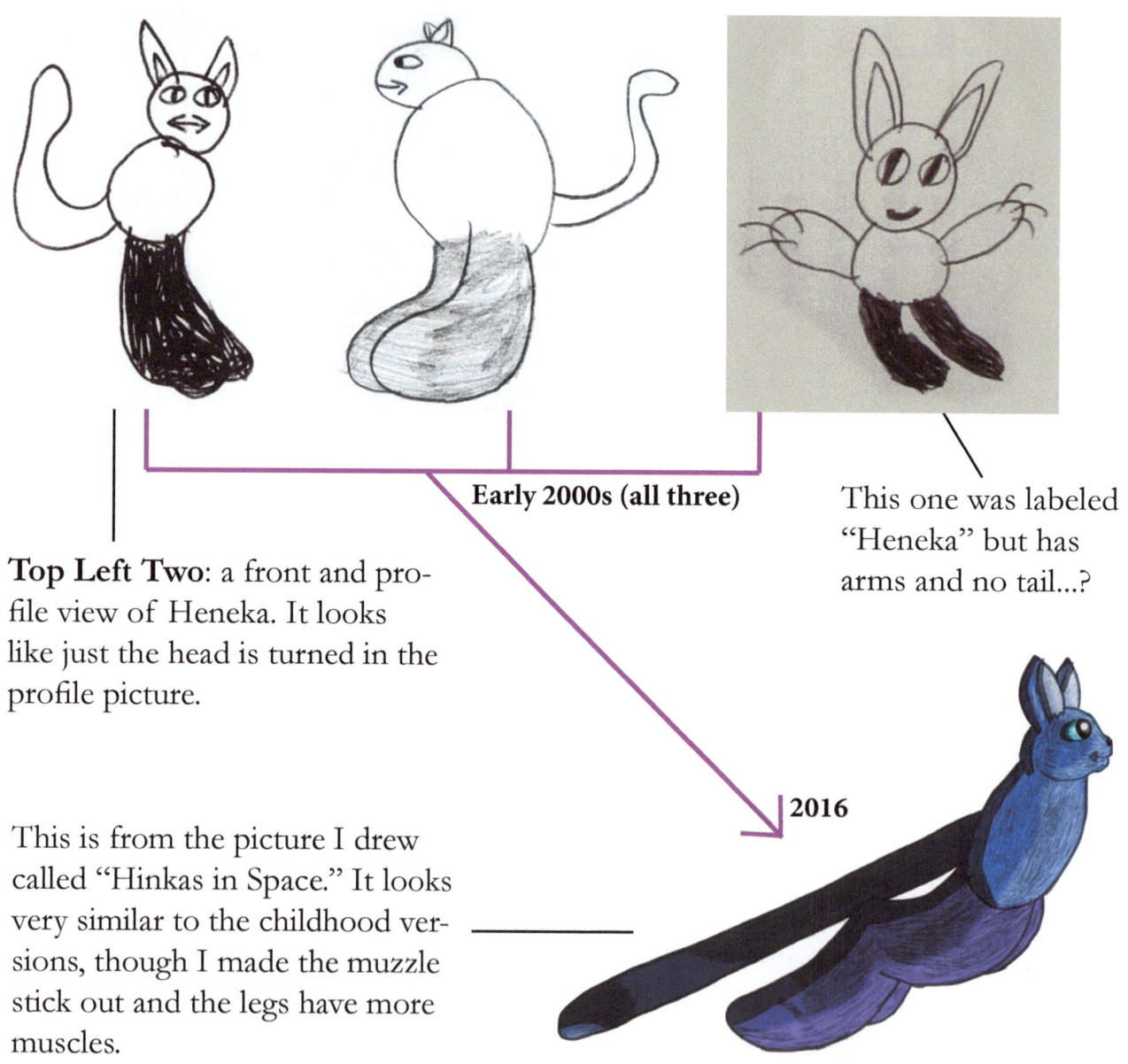

Early 2000s (all three)

This one was labeled "Heneka" but has arms and no tail...?

Top Left Two: a front and profile view of Heneka. It looks like just the head is turned in the profile picture.

2016

This is from the picture I drew called "Hinkas in Space." It looks very similar to the childhood versions, though I made the muzzle stick out and the legs have more muscles.

Cat Hinka 6: Kitticloud

Kitticloud (kitty-cloud) is a hinka that I don't actually remember drawing. It's one of those that I drew only once and never again. The reason I drew it again as an adult is because my sister liked it so much (one of the birthday presents I gave to her when I was a child was a booklet with a bunch of hinka drawings and kitticloud was included in it).

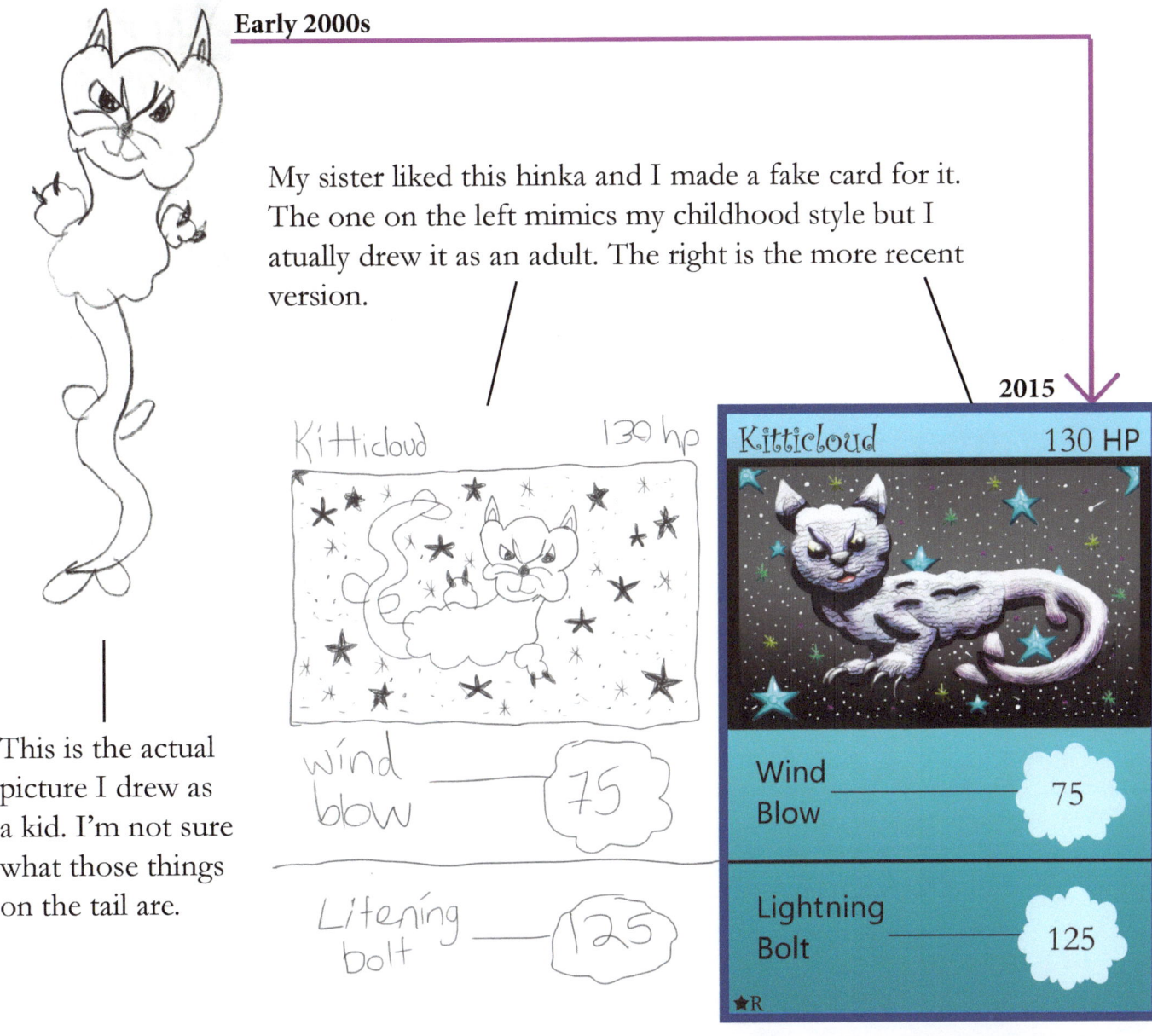

Early 2000s

My sister liked this hinka and I made a fake card for it. The one on the left mimics my childhood style but I atually drew it as an adult. The right is the more recent version.

2015

This is the actual picture I drew as a kid. I'm not sure what those things on the tail are.

Hinkas Through the Ages

Cat Hinka 7: Anthro Cats

The term "anthro" (short for anthropomorphized) refers to animals who have human-like traits (in this case, standing on two legs and having arms and hands like people). I didn't draw any anthros as a kid because I wasn't a fan of them until I got into high school. The transition in this chapter isn't actually a direct transition (i.e. I didn't draw the same character later on); it's to show how my style of drawing a singing cat changed from high school to college.

High School Versions

Almost all the anthro cats I drew in high school were singing cats. I went through a phase where I drew a lot of these during my classes.

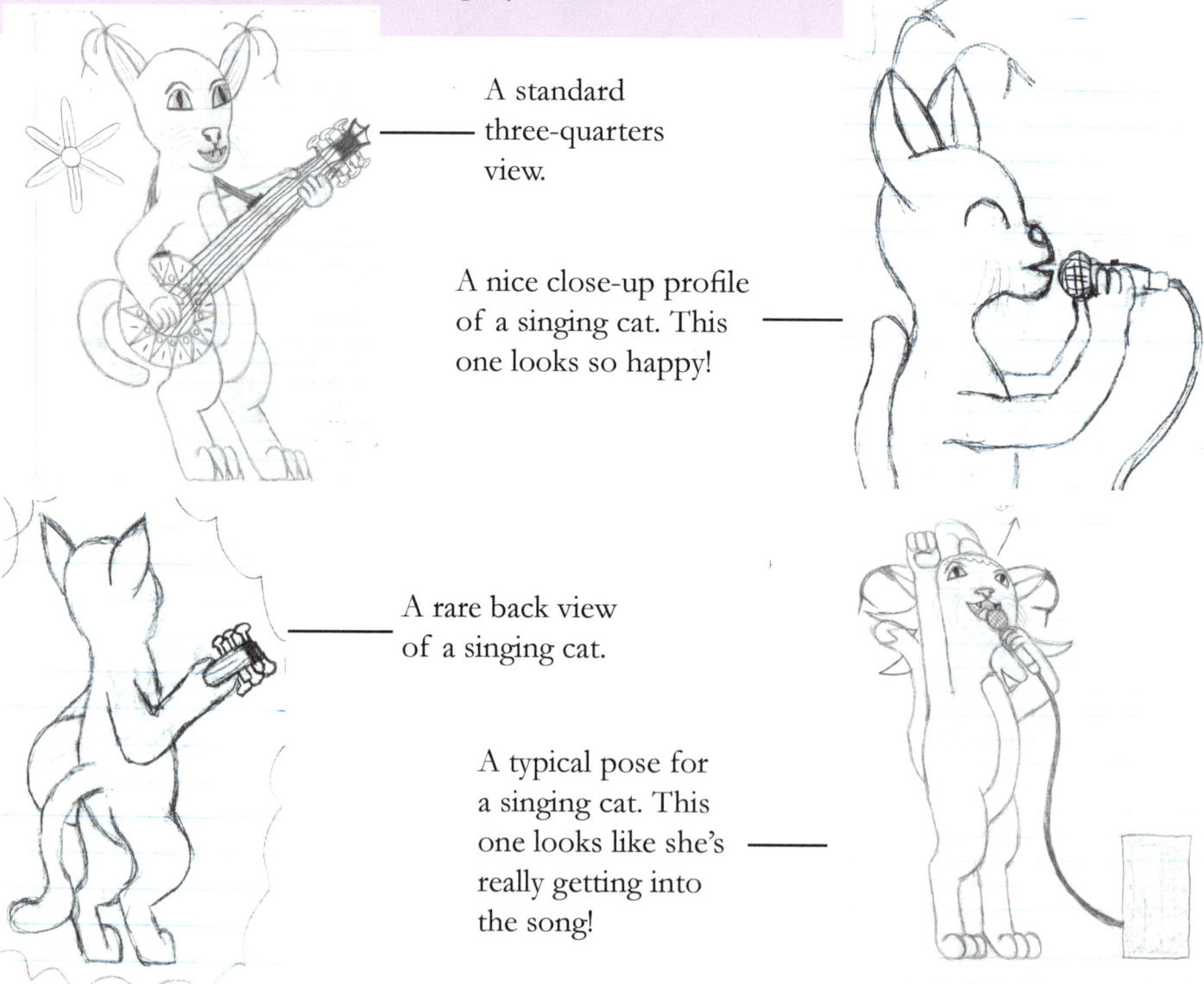

A standard three-quarters view.

A nice close-up profile of a singing cat. This one looks so happy!

A rare back view of a singing cat.

A typical pose for a singing cat. This one looks like she's really getting into the song!

Adulthood Versions

These are a couple of examples of anthro cats I drew as an adult. I haven't drawn too many anthros as an adult, so this is an area I'll explore more in the future.

This is a "summoner cat." She's beckoning you to come along and see all the cool magic she can conjure up!

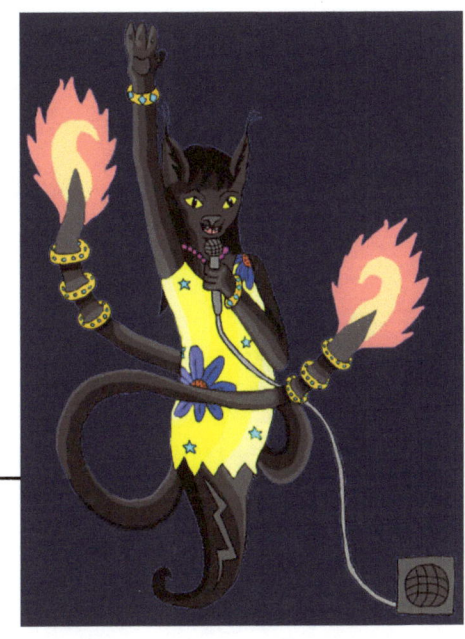

The only "singing cat" I drew as an adult. She doesn't have legs because I remember I didn't know how to draw them well. And she has two tails because why not?

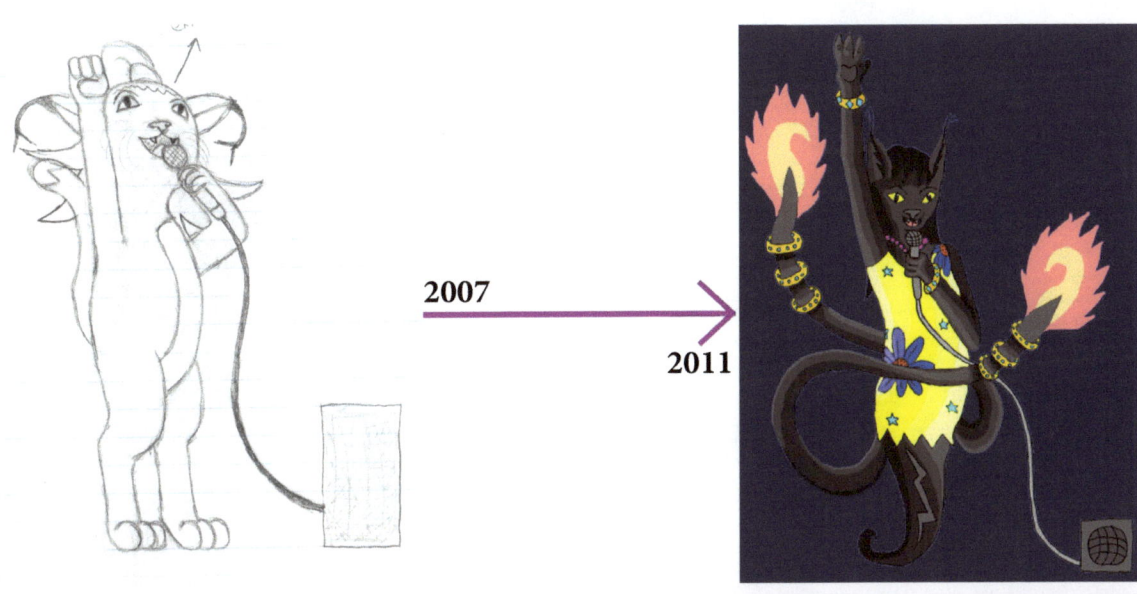

2007

2011

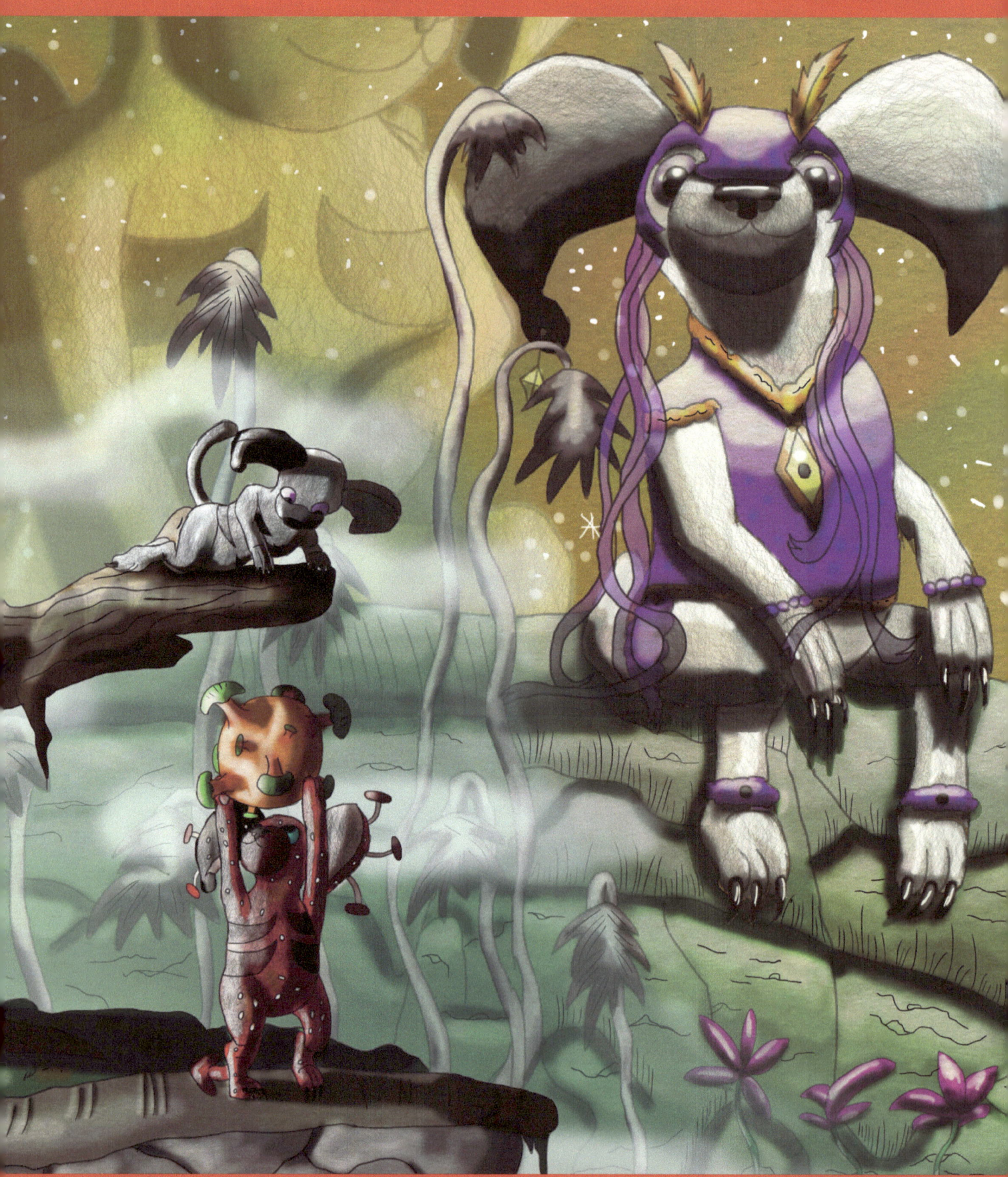

Chapter 2: Rodents

My family had a lot of gerbils when I was a kid so I am no stranger to these little critters.

Rodents includes my #1 drawn hinka ever: kikacoons. I was so obsessed with this particular species that I drew it not only a bunch of times as a kid but also a bunch of times as a teen and as an adult.

This section also inlcudes squirrels, mice, and other related hinkas. A couple of them don't resemble real-life animals but I'll call them rodents anyway. Close enough.

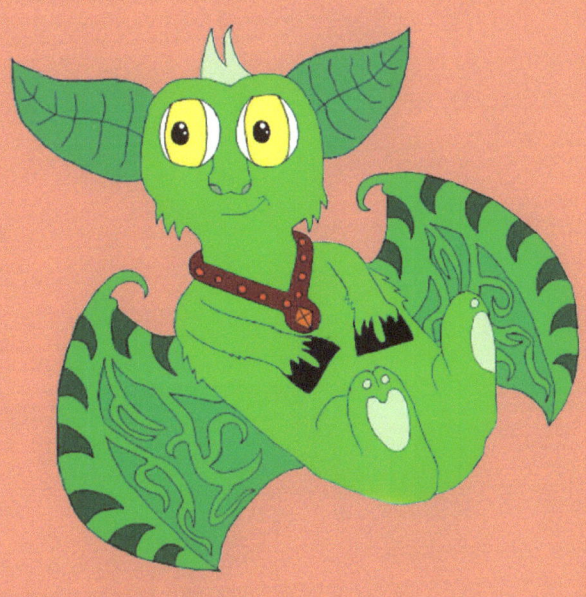

Hinkas Through the Ages

Rodent Hinka 1: Kikacoons

Kikacoons (KEY-kuh-coon) are flying mice with insect-like wings. Originally the "kikacoon" was its own species and there were related species such as kikangels and kikabumbles. However, I've recently decided that there are so many cool variations to kikacoons that the term "kikacoon" should be treated more like "feline" or "canine"—basically describing a whole group of species of flying mice that are related to each other. There may be the original "kikacoon" but I'll have fun developing all kinds of related species!

Childhood Versions

I created kikacoons back in the late 1990s. I drew them hundreds of times over the years. I've included a wide variety of examples to try and show the variations between them.

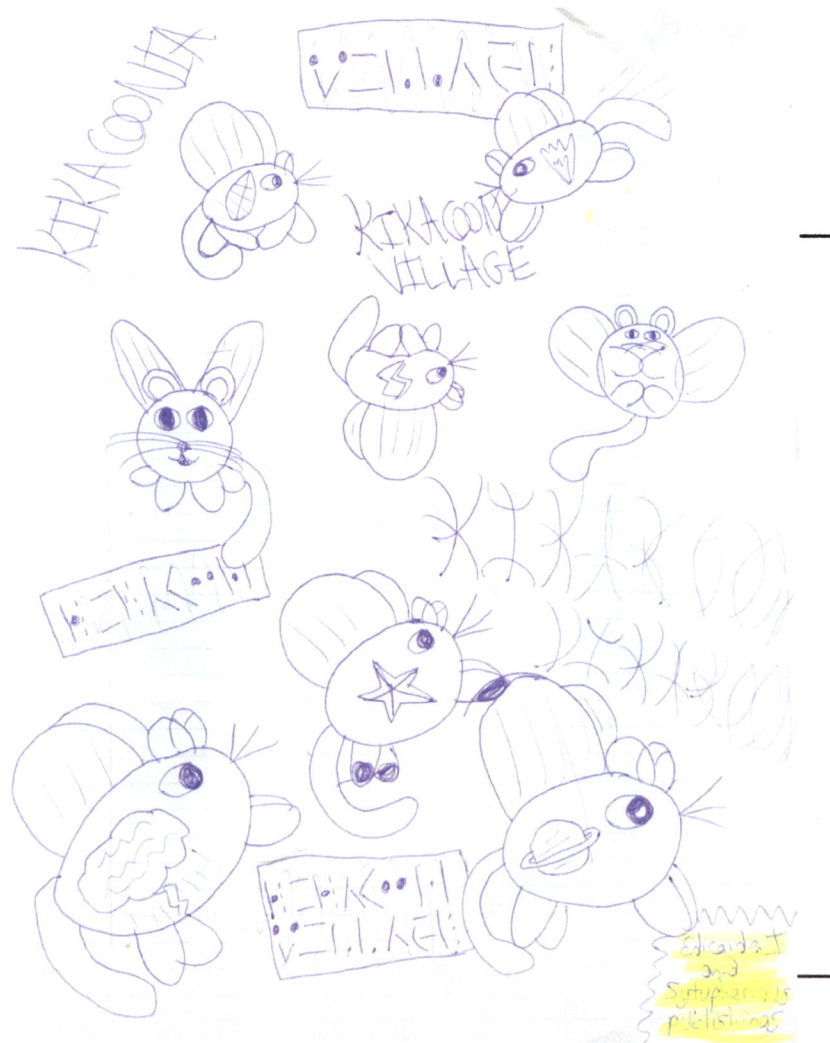

Here are some examples of very standard poses for the kikacoons. These ones are unusual in that they have symbols on the sides of their bodies, but they look really standard otherwise. The strange letters are part of a "made-up" language of mine.

I had several "publishing companies" when I was a kid. "Edicaida and Sytupherious Publishings" was one of them. They are antagonists in a story I wrote as a kid. See p. 60 for a picture of Edicaida.

Here are some variations on the original kikacoon. Most of these have very minor changes but they are all different species from the original kikacoon.

Kikangel

What is going on here???

Hoopycoon

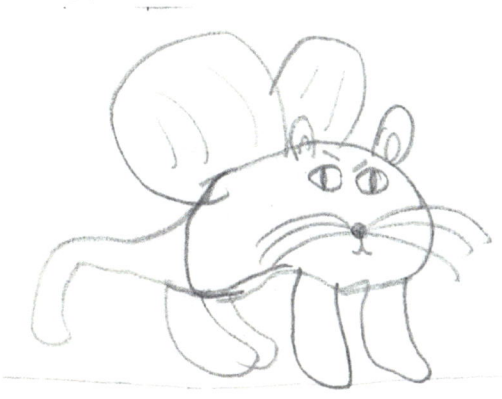

Horntcoon

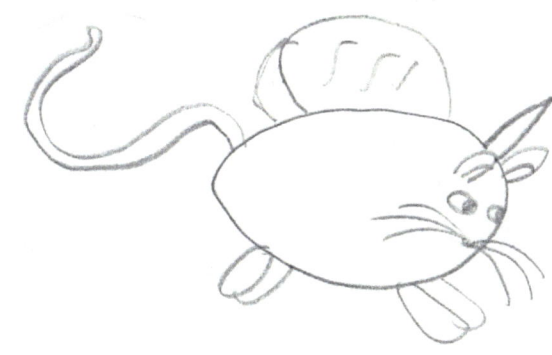

Crystalcoon

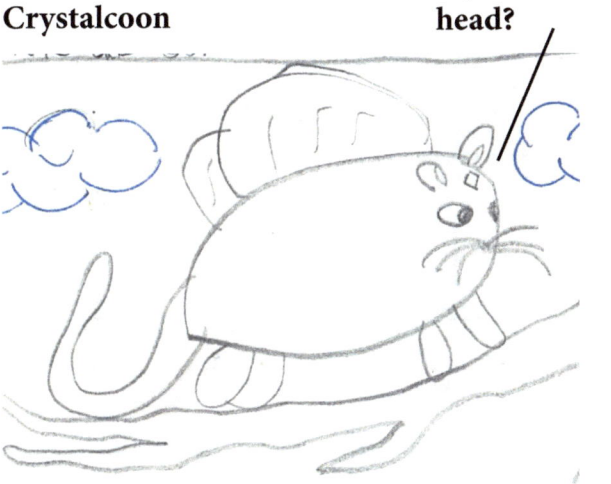

See that tiny crystal on its head?

Bumblecoon

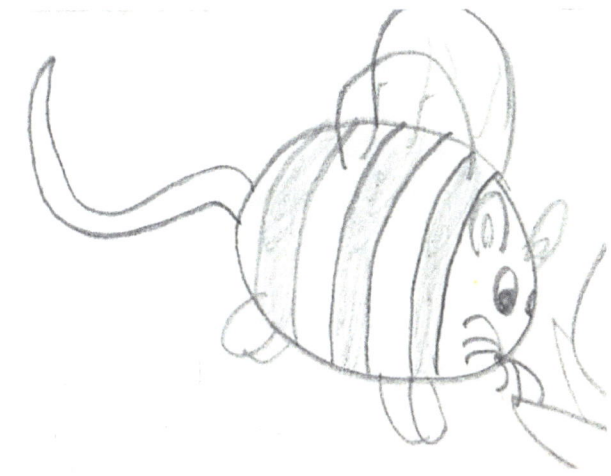

Kikabumble

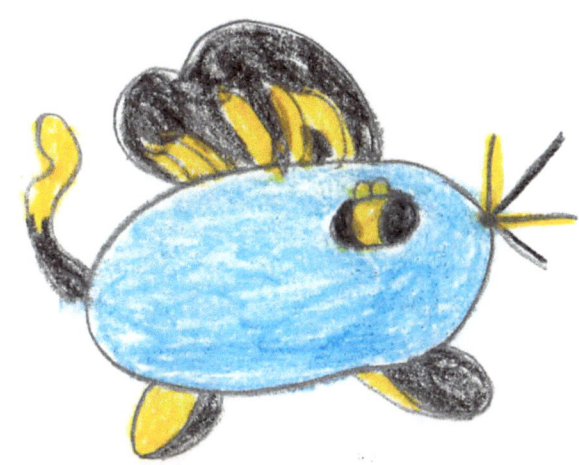

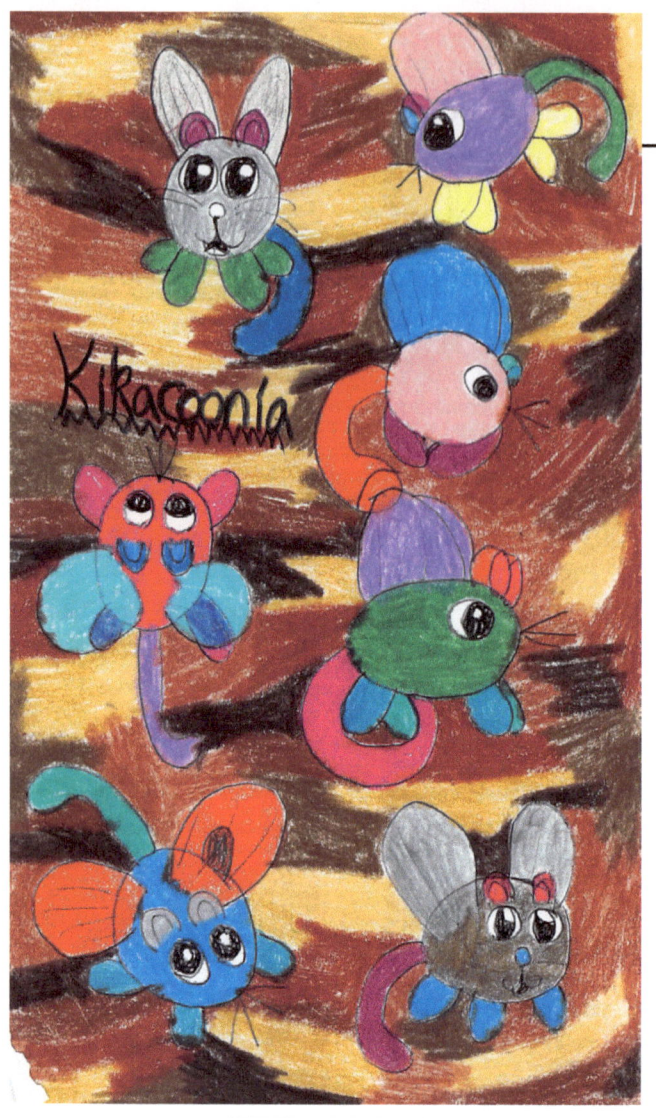

This is a wonderful example of different colored kikacoons. I love all the color combinations!

Bottom Three: Firecoon, Icecoon, and Boltcoon were a trio of characters I came up with for a childhood story I wrote.

Firecoon

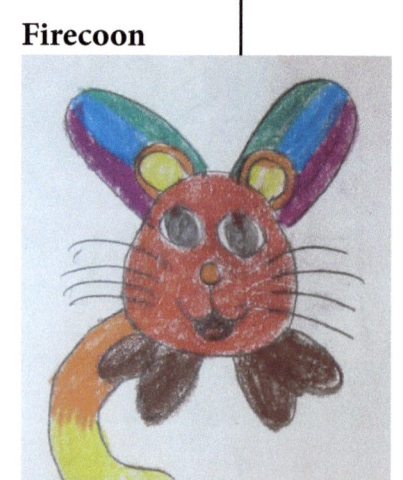

Icecoon

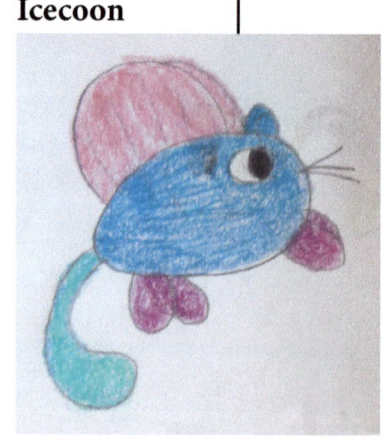

Boltcoon

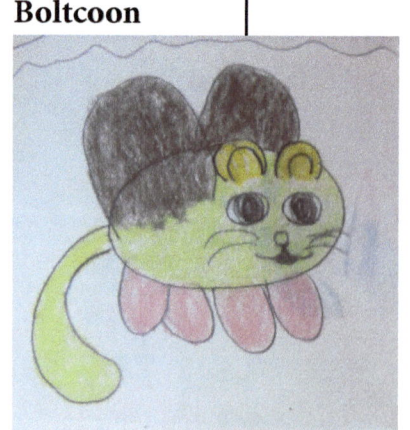

This is a kikacoon character called "Kikacoon de Two (TWO-oh)." Anything "de Two" was supposed to be very powerful.

This is the kikacoon character "Kuekacoun" (KWEH-kuh-cown). I love the color combination!

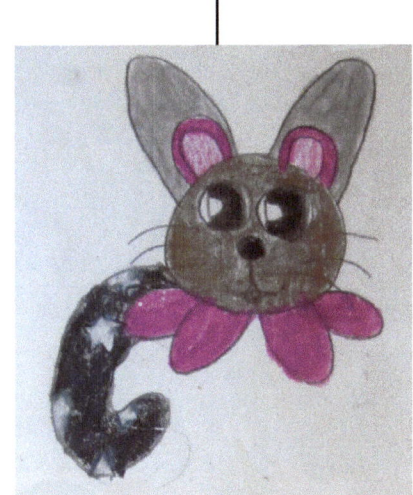

High School Versions

These are examples of kikacoons I drew in high school. There was a little bit of change in the anatomy (see right picture) but I didn't really explore different ways of drawing kikacoons until adulthood.

A standard-looking kikacoon —but with more details!

A kikacoon with "shading." I didn't quite grasp the concept of shading until later in life.

A more "realistic" version of a kikacoon.

Adulthood Versions

I came up with several different versions of kikacoons as an adult. It was interesting trying to figure out how to make more realistic versions of the original childhood version.

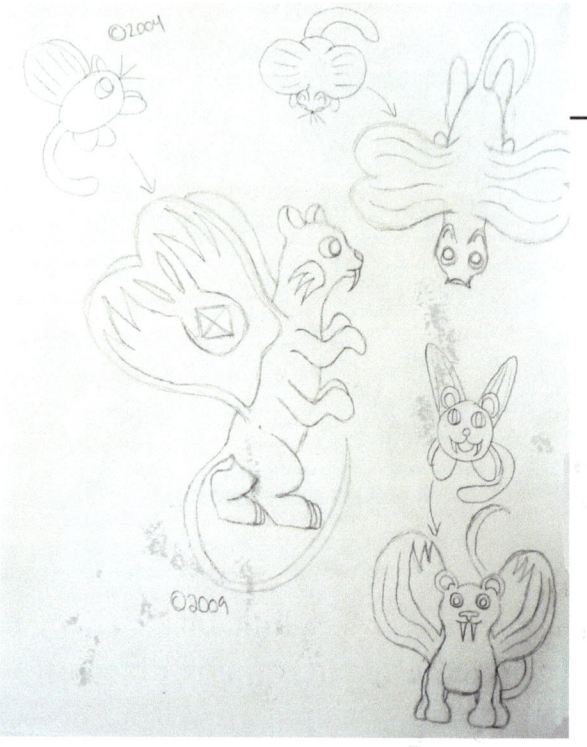

This is the only time I drew kikacoons with six legs. Since they have fly-like wings, I wanted to make them more insect-like. I'm not sure why I didn't try this style more than once.

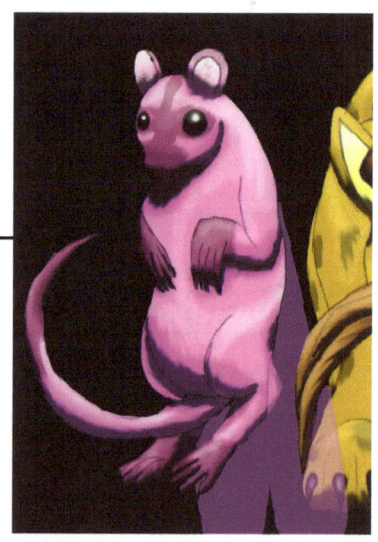

A standard mouse with fly-like wings. (The cat next to this kikacoon is creainka; see full picture on p. 15).

A standard mouse with fly-like wings. But look at those cool wing veins! This is from "Hinka and his Buddies" (see title page).

A standard mouse with fly-like wings. But look at those cool costa (wing edges)! This is from a picture I drew called "Psydonvex (sigh-done-vex) Hill."

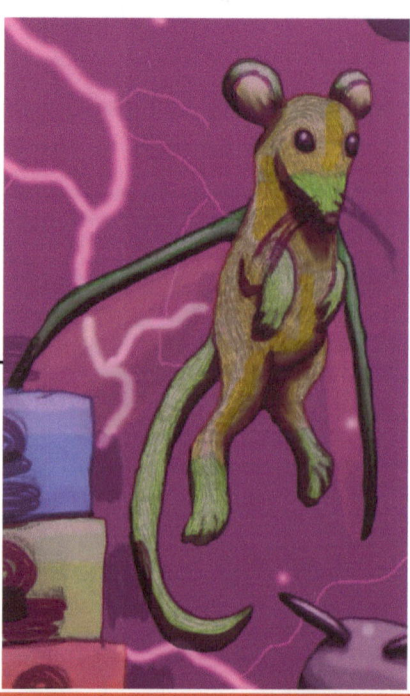

Rodents

Kikacoon appeared in a comic I created which featured a creainka (see pages 14-15). Kikacoon was captured by a "bad guy" named Tornacane and was saved by the hero, Creainka (name of character AND species). The kikacoon's name in this comic is "Kikacoon" because I'm super creative!

Nice front view picture of the "kidnapped" Kikacoon.

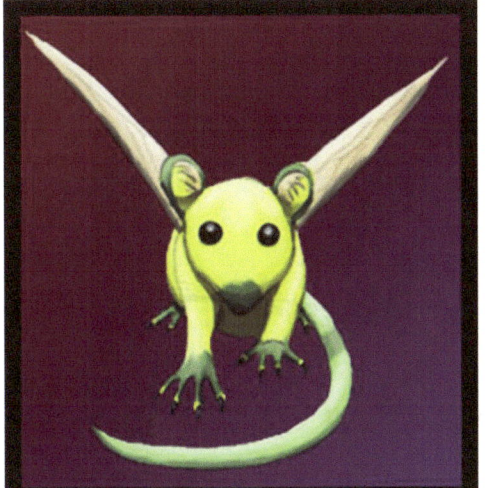

Kikacoon stuck in a cage. She's so cute in this picture!

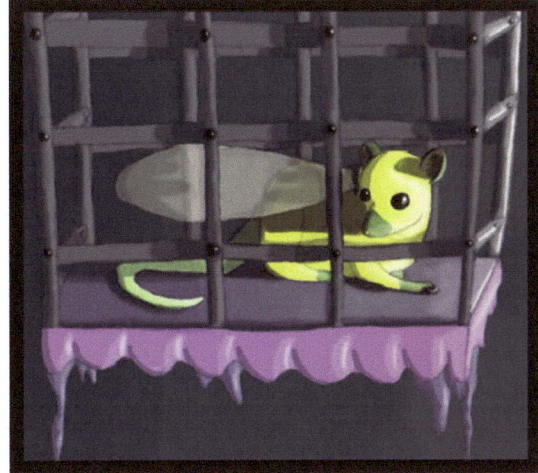

Kikacoon held by the "bad guy," Tornacane.

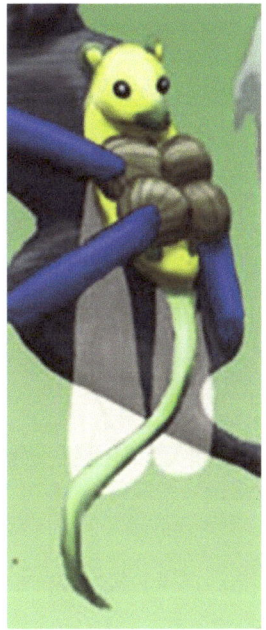

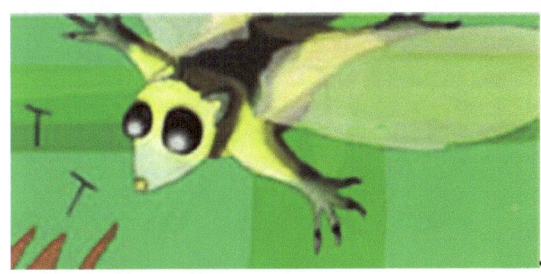

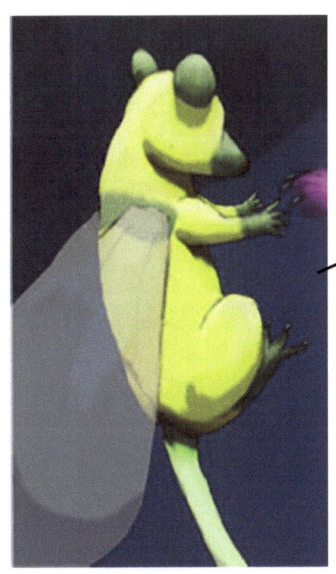

Kikacoon being thrown away from Tornacane after being hit by magic from Creainka

Kikacoon going on an adventure with her hero, Creainka.

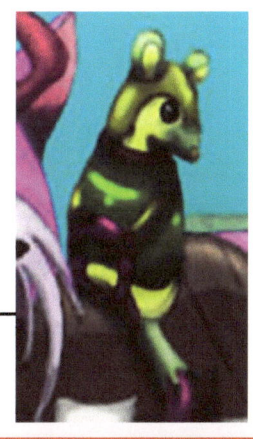

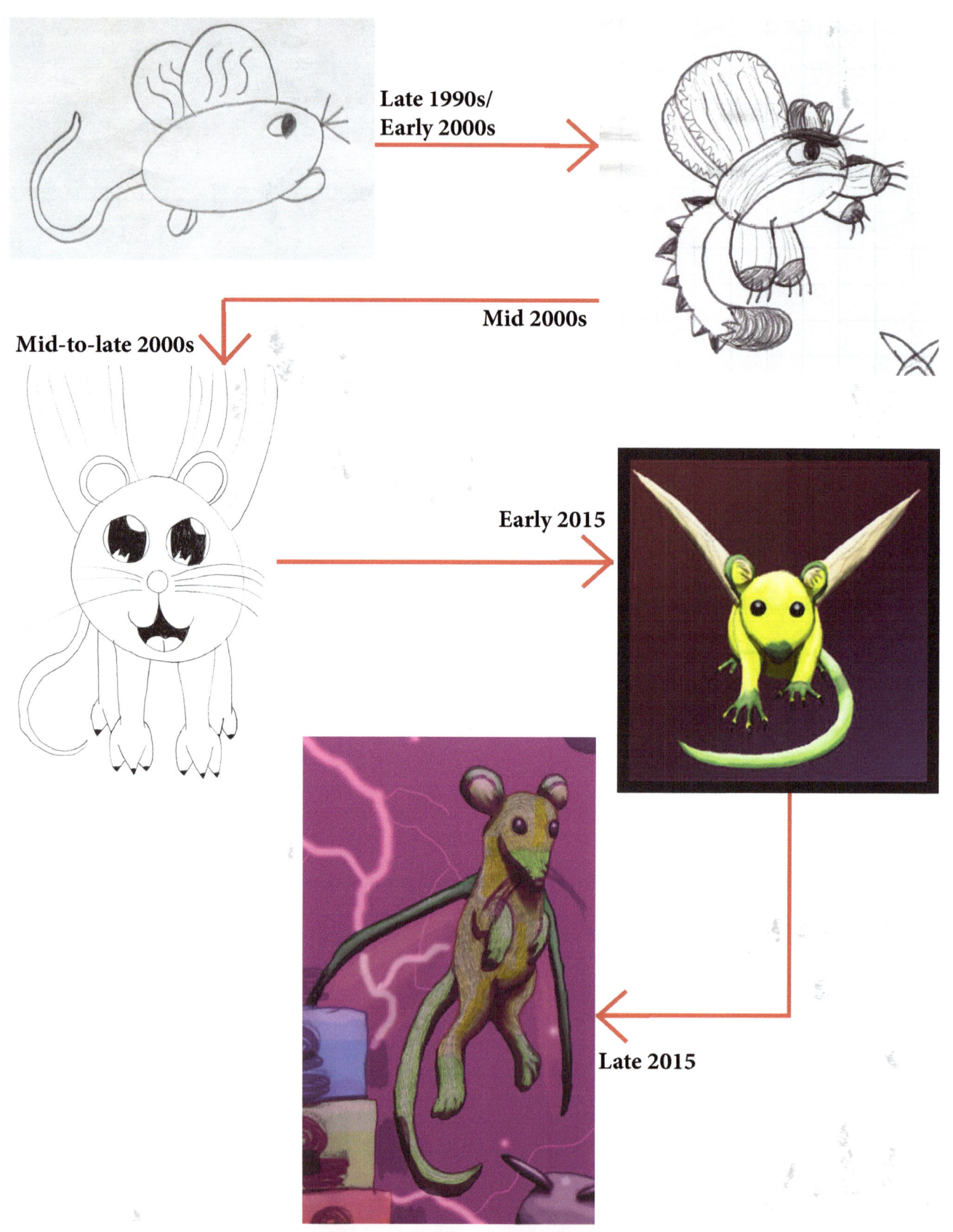

Rodent Hinka 2: Hankia

Hankia (HANK-ee-uh) was a main character in a story I was writing as a child. His design is very interesting—it's clear that his head is that of a cat (but I clearly remember he was a "spring mouse" as a child so I'm categorizing him as a mouse) but the rest of the body is just a bunch of blocks with springs. The springs can fly off and attack enemies so they're useful...but how in the world does this hinka even balance? Maybe the boxes are all hollow so most of the weight is in the head?

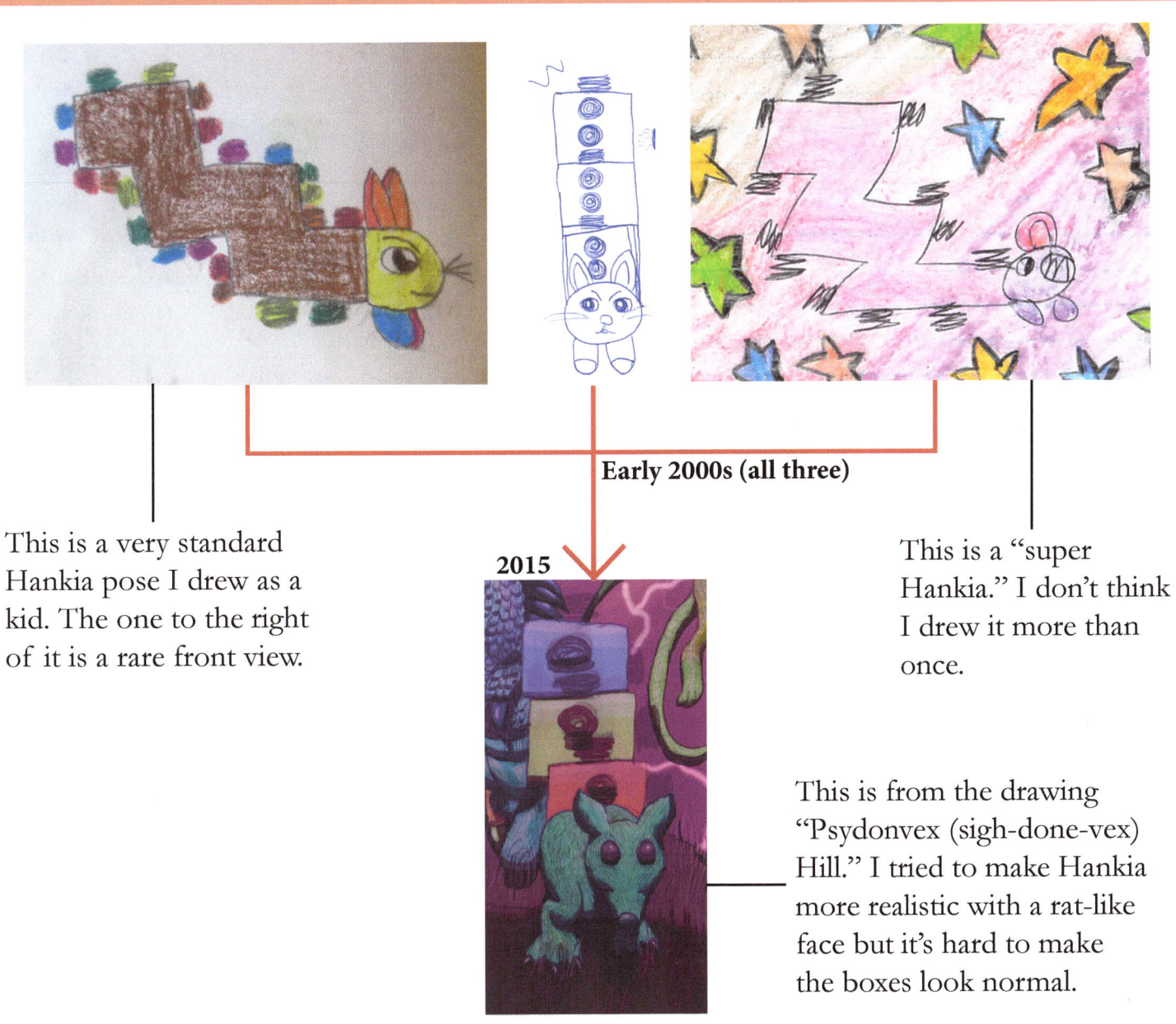

Early 2000s (all three)

2015

This is a very standard Hankia pose I drew as a kid. The one to the right of it is a rare front view.

This is a "super Hankia." I don't think I drew it more than once.

This is from the drawing "Psydonvex (sigh-done-vex) Hill." I tried to make Hankia more realistic with a rat-like face but it's hard to make the boxes look normal.

Hinkas Through the Ages

Rodent Hinka 3: Quemo

Quemo (kem-oh) was a species I introduced in high school. I first drew a character named "Zoquem" in a comic I made back in high school. I decided I liked the design so much that I decided to draw it some more.

I call this a "rodent" because the tail looks squirrel-like. I don't know how well an animal designed like this could survive in the wild, but I think it's pretty cute.

High School Versions

Because I introduced this species in high school, I had a fairly good grasp on anatomy. I drew the same pose many, many times but I was able to find a few cool variations.

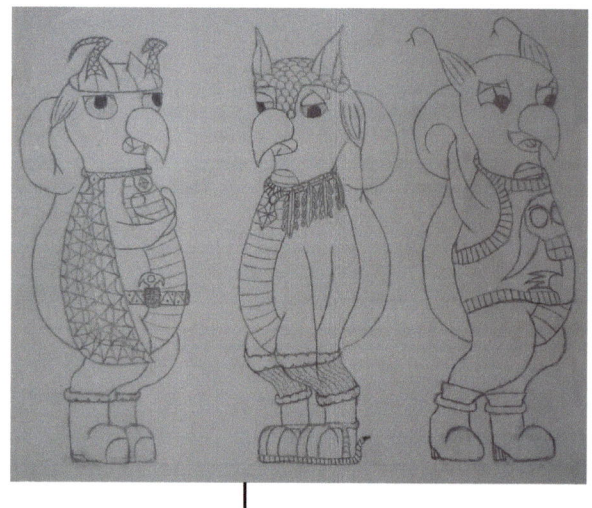

The left one is Marquem and the middle is Tinquem. I didn't have a name for the right one, but it also would have ended in "quem."

I didn't draw this pose very often. In fact I'm don't remember drawing it more than this once!

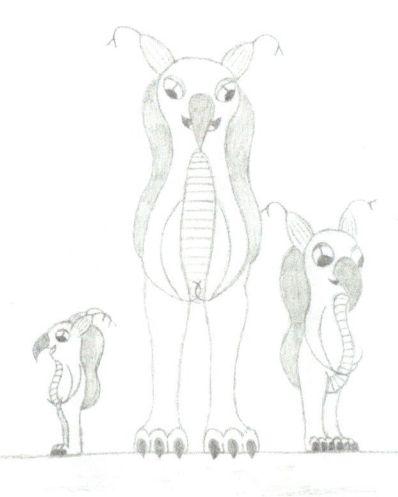

The three different sizes represent different life stages.

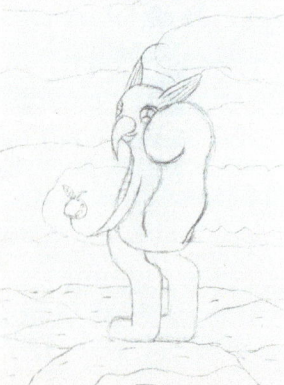

I drew this pose several times because I thought it looked awesome.

Rodents

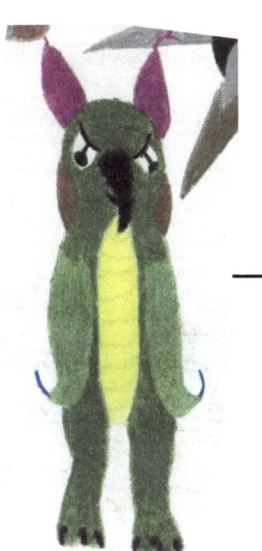

A standard colored front view for the character Zoquem. He looks very squished in this picture.

A quemo jumping in the air. I drew this only once that I can remember. It's nice to see action poses!

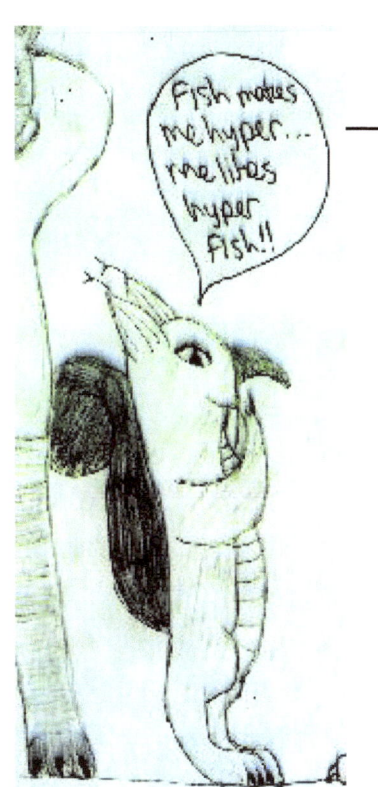

This was from a comic I made back in high school of Zoquem. In this picture, he's saying "Fish makes me hyper...me likes hyper fish!!"

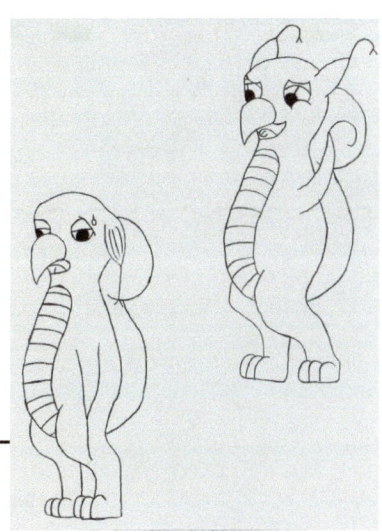

A couple of poses showing different quemo emotions. The one on the left is "disappointed" and the one of the right is "excited."

A quemo sitting on a branch holding a tiny apple. It looks so excited to eat the apple!

33

Adulthood Versions

I didn't draw quemos very much as an adult. I guess it was more of a high school thing. I do like the design and wouldn't mind creating more artwork with this hinka in the future.

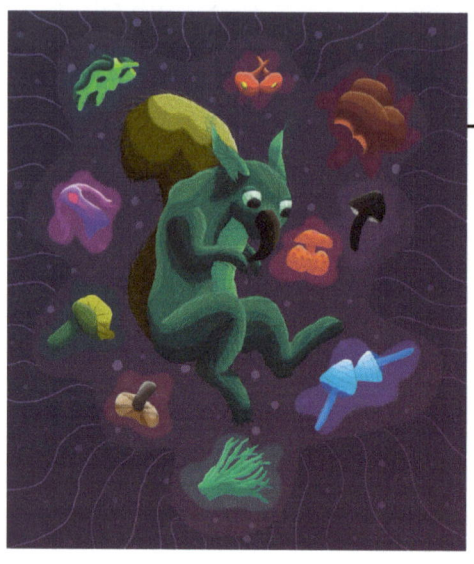

This is Maraquem, the "creature deity" (a being born as a creature but given the power of a deity later in life) of fungi. She is not the same character as Marquem on p. 32.

A redrawn version of Zoquem.

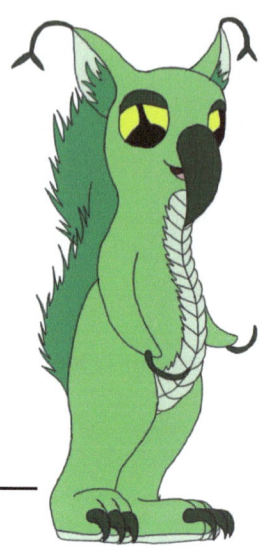

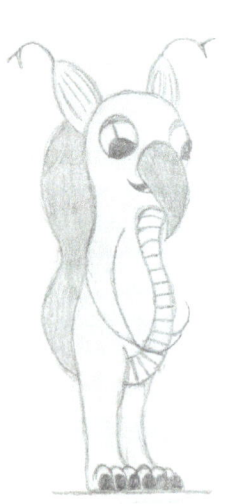

Mid- to- late 2000s

2016

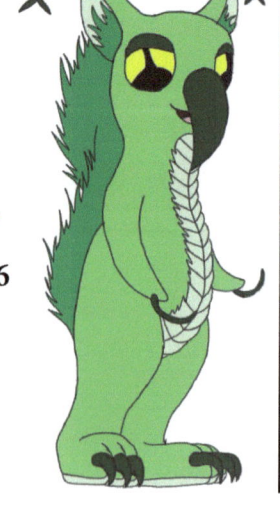

There's very little difference between these two. I didn't want to differentiate too much from the original design since I really liked it.

Rodent Hinka 4: Squire Ella

Squire Ella was a character I'm pretty sure I developed in high school but I didn't start drawing her until college. Her design is based on a giant black squirrel. She carries around a bow and arrows but rarely shoots anyone because she feels that that's impolite. It's more for show than for attacking or defense.

She's a character I would like to redraw in the future!

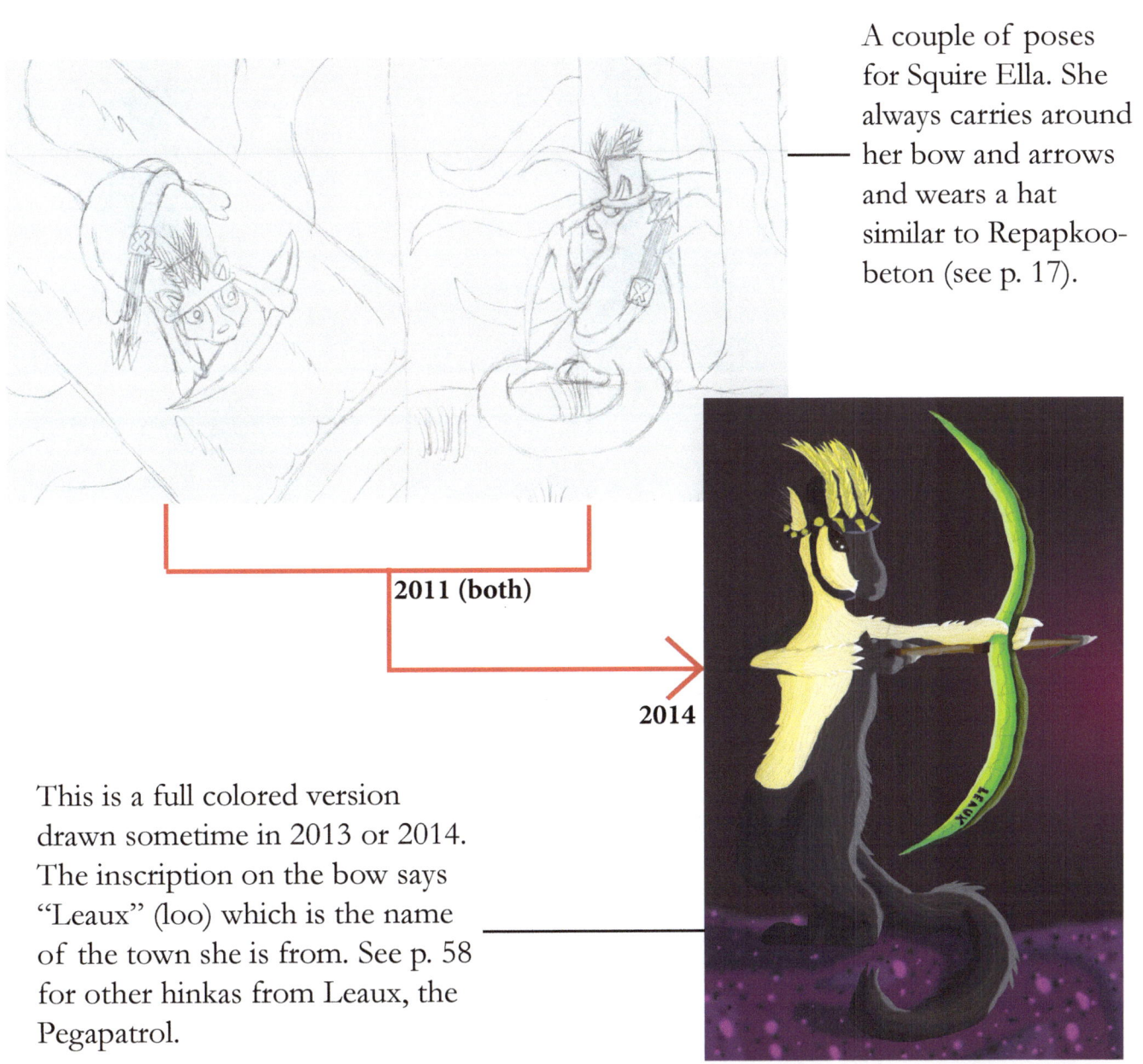

A couple of poses for Squire Ella. She always carries around her bow and arrows and wears a hat similar to Repapkoo-beton (see p. 17).

2011 (both)

2014

This is a full colored version drawn sometime in 2013 or 2014. The inscription on the bow says "Leaux" (loo) which is the name of the town she is from. See p. 58 for other hinkas from Leaux, the Pegapatrol.

Hinkas Through the Ages

Rodent Hinka 5: Grelerod/Broledee

This is a hinka I drew only once. I really liked the design so I decided to redraw it...twice. This rodent version was drawn first and I named it "grelerod" (greh-leh-rod) short for "green leaf rodent." The deer version was drawn second and I named it "broledee" (bro-leh-dee) short for "brown leaf deer."

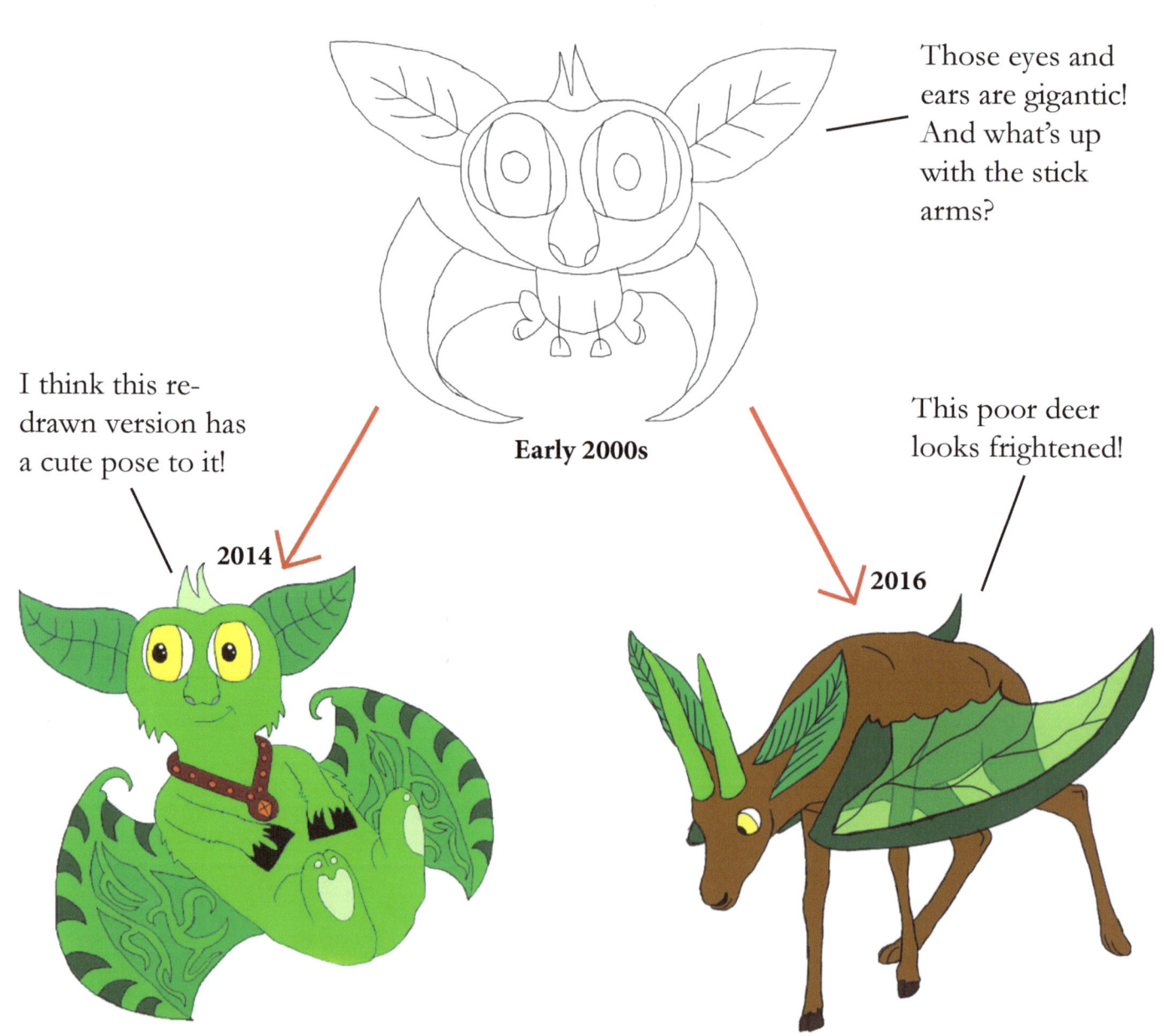

Those eyes and ears are gigantic! And what's up with the stick arms?

Early 2000s

I think this re-drawn version has a cute pose to it!

2014

This poor deer looks frightened!

2016

36

Rodent Hinka 6: Rinatues

Rinatues (rin-uh-twos) are the "jesters" of the hinka world. I really like the black and white design of this hinka, which I why I chose to redraw it later as an adult.

It was hard to tell what kind of creature the original childhood version looked like. I chose to redesign it based on Tasmanian devils (they're marsupials, but close enough) because the "open mouth" on the childhood version translated well to a darker muzzle.

Early 2000s

This is the childhood version of rinatue. This is the only pose I ever drew. I'm pretty sure the dark circle on the face is an open mouth.

This is the compilation picture called "Rinatues" based on the redraw (bottom left).

2016

I based this new design loosely on Tasmanian devils.

2016

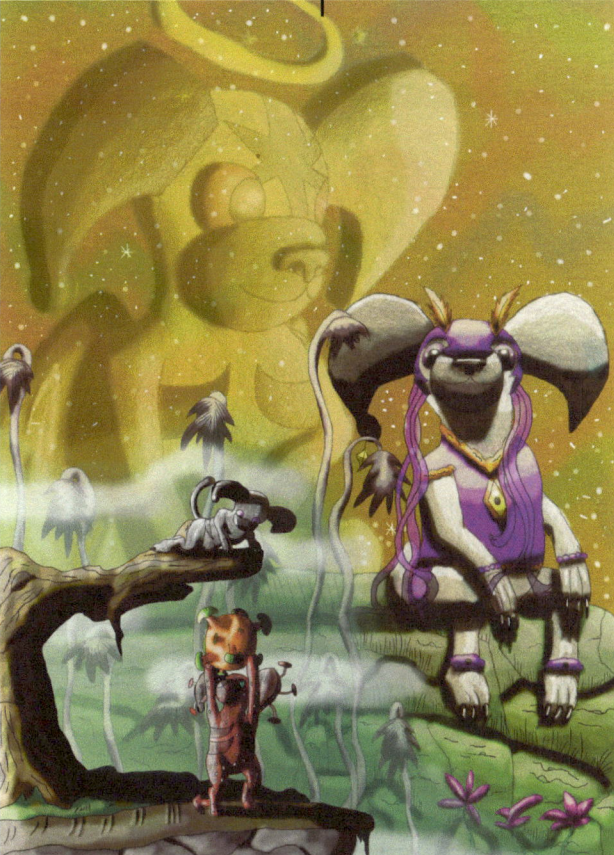

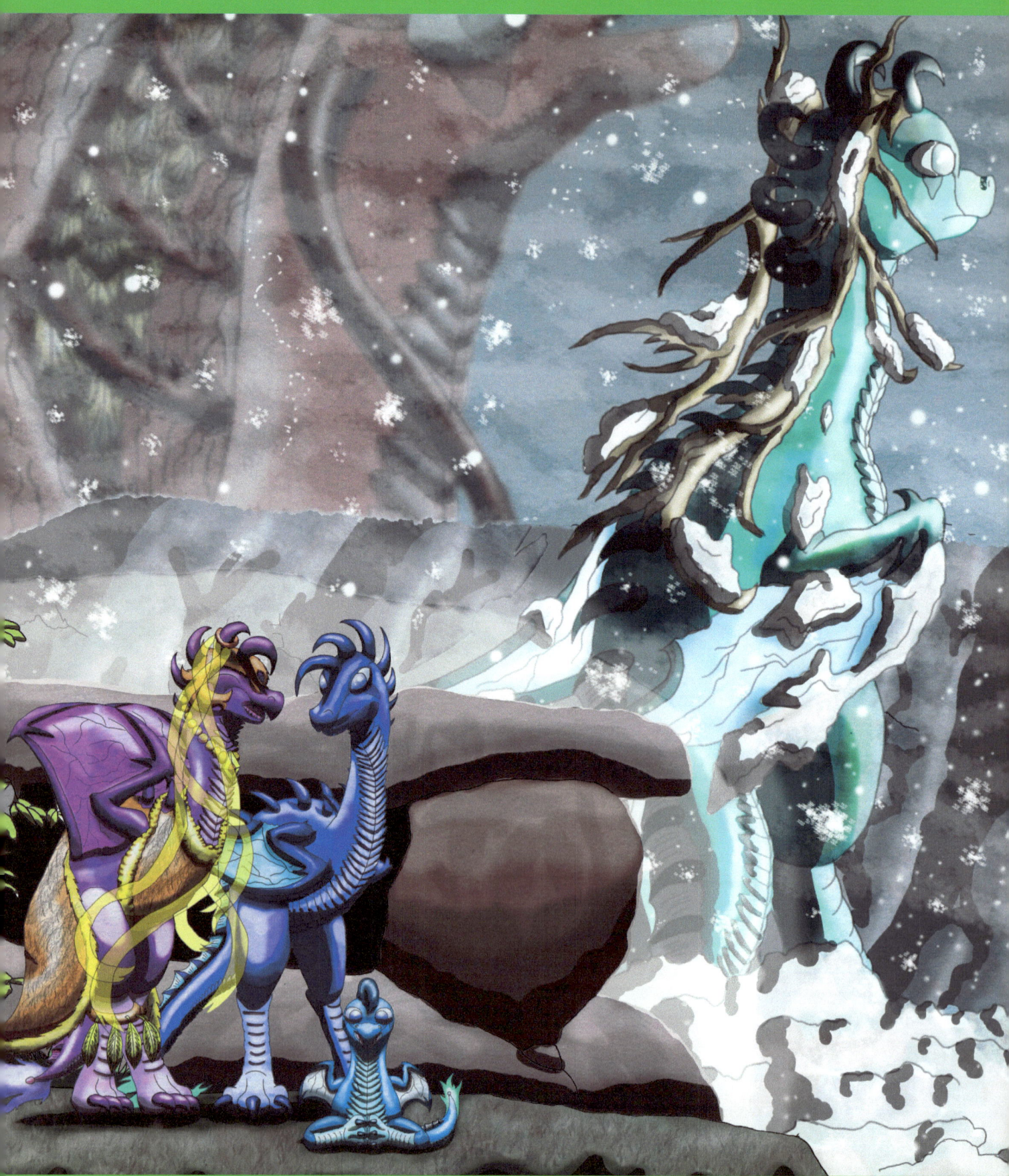

Chapter 3: Reptiles

Reptiles were something I didn't draw as often as mammals as a kid, but there were a few reptilian hinkas that I liked to draw a lot during my childhood.

As an adult I've drawn many different dragons but there were really only two species of dragons I drew as a kid: hooved dragons and star crested dragons. I guess I liked their designs so much I didn't bother drawing any other type of dragon.

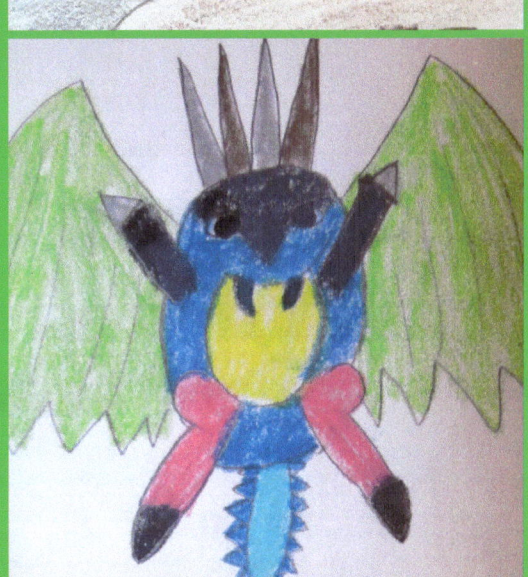

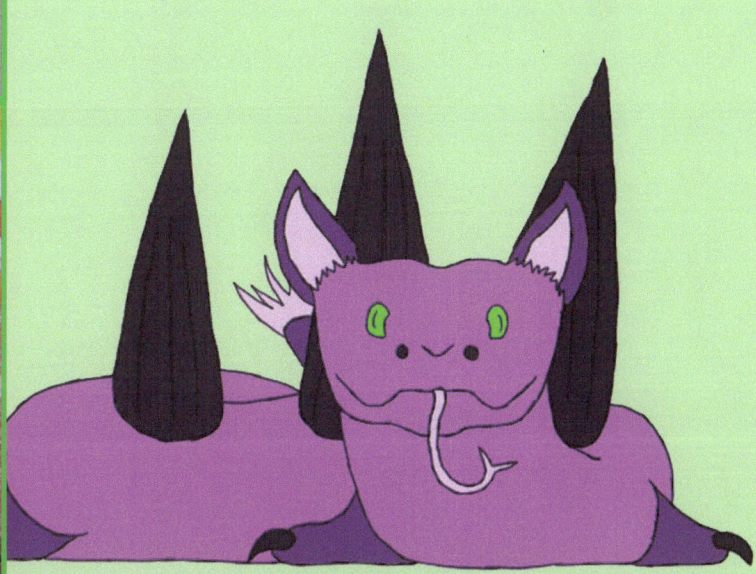

Hinkas Through the Ages

Reptile Hinka 1: Hooved Dragons

Hooved dragons were a hinka that I was obsessed with as a child. They were one of my personal favorites and I drew them so many times. The childhood versions are extremely cute and the later versions I tried making look more like "dragons" (but I always kept the hooves). One character named "Sansirama," (san-sire-AW-muh) aka San (p. 42), was a hooved dragon who appeared a lot in stories I wrote as a kid. He was very grumpy.

Childhood Versions

These are a few examples of hooved dragons I drew as a kid. I love how the hooves are so big on all of them.

I generally drew these dragons sitting so it was cool finding one in a standing pose.

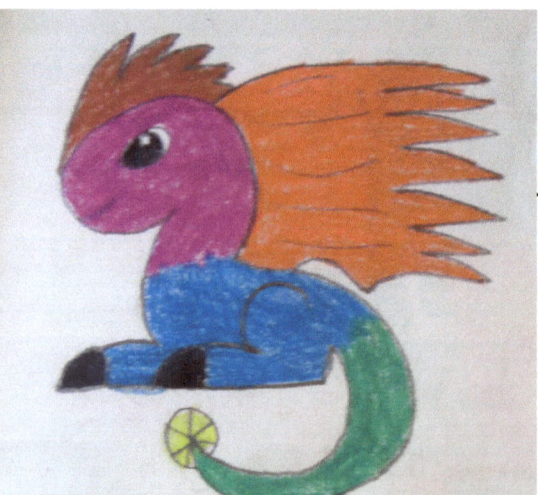

A typical sitting pose for a hooved dragon.

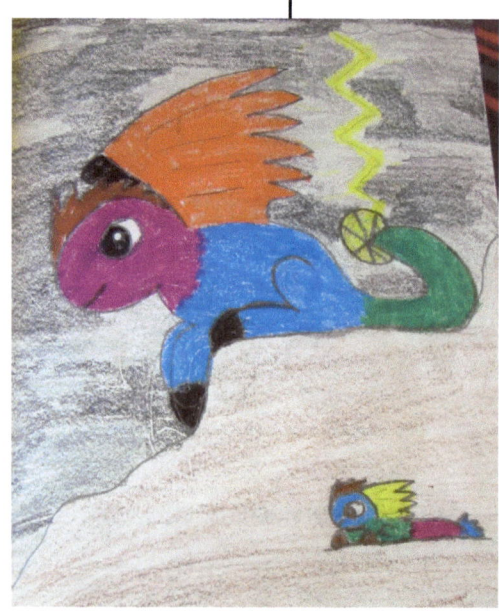

This picture is really cute because the hooved dragon has a little baby nearby!

High School Versions

There wasn't a huge change between childhood and high school versions of hooved dragons, but in high school I got a bit better hold of anatomy and adding details.

Here are five hooved dragons in different poses. I always liked it when I tried different poses for hinkas rather than drawing the same one over and over again (which I tended to do as a child).

All three of these have the same pose, but I really like the space design on the left one, the colors on the middle one, and the background on the right one.

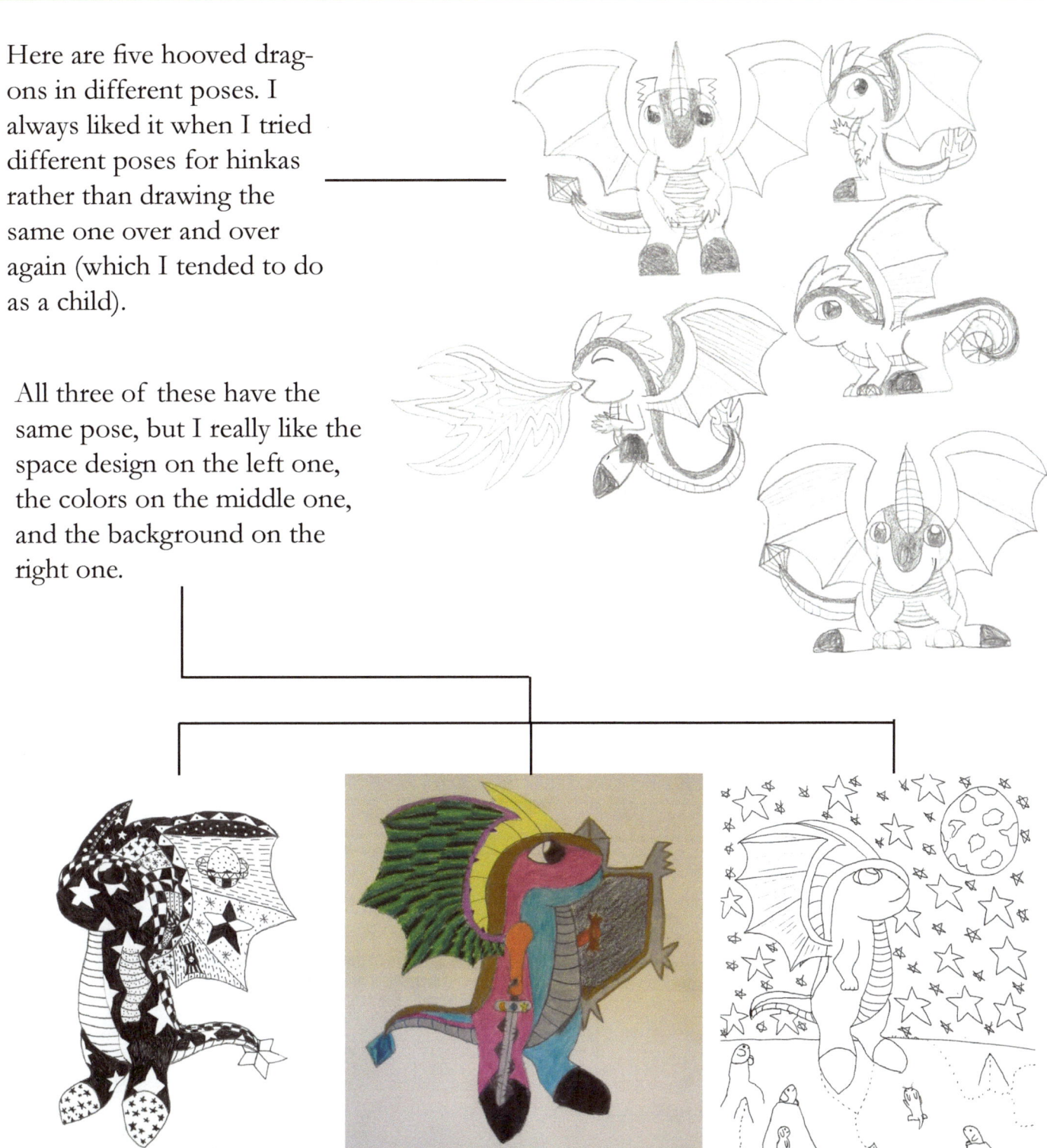

Hinkas Through the Ages

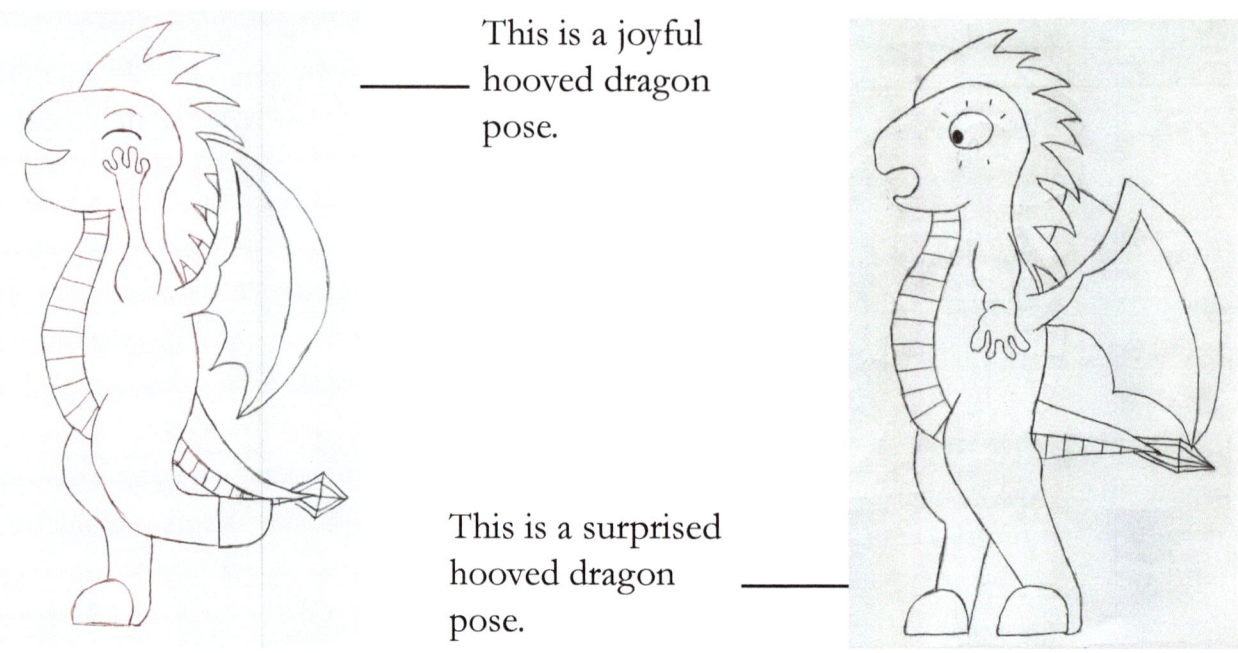

This is a joyful hooved dragon pose.

This is a surprised hooved dragon pose.

Adulthood Versions

I didn't draw too many hooved dragons as an adult. But the ones I did draw turned out quite nice. The two pictures below are of the character Sansirama.

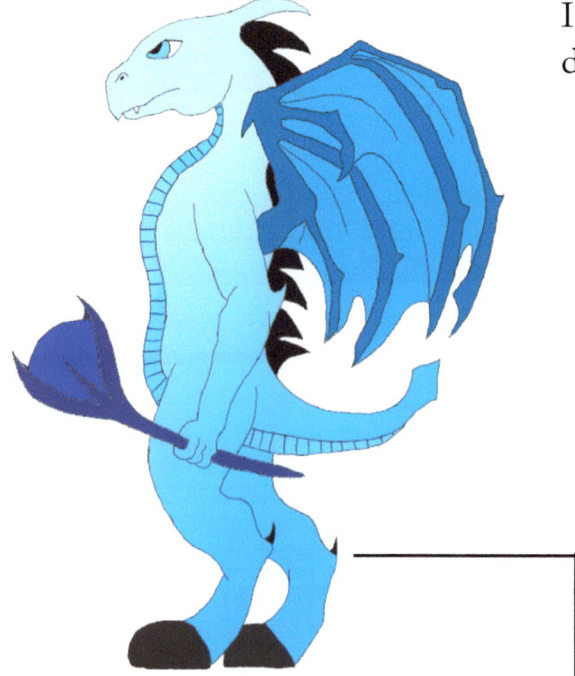

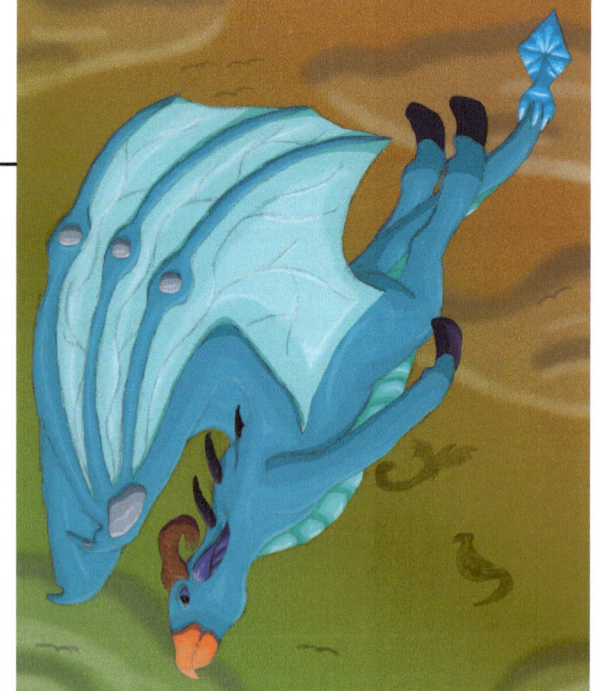

I wanted to do a flying pose and thought a descending pose would look cool.

I tried to make a "realistic" hooved dragon. I really like the way this one turned out, though the wings are awfully small.

Reptiles

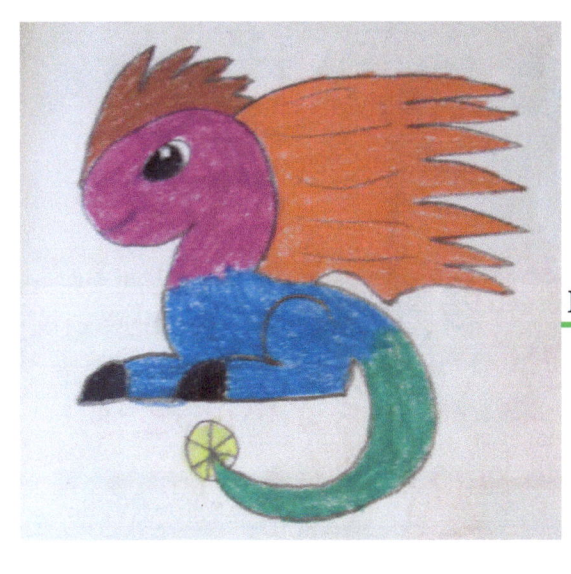

Early 2000s

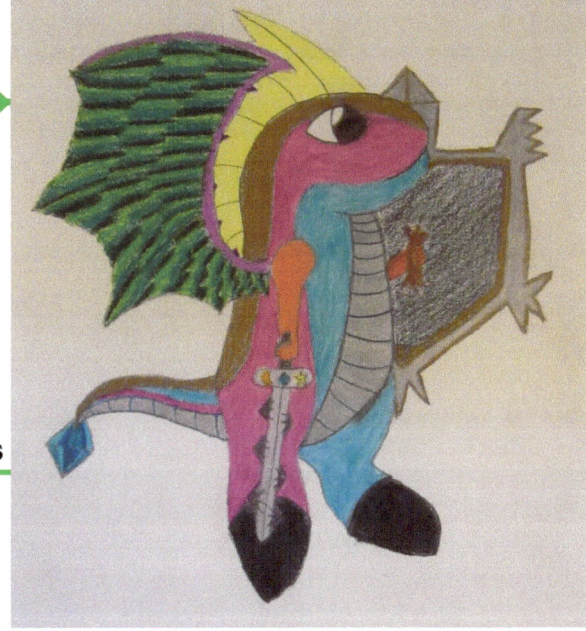

Mid- to late-2000s

2009

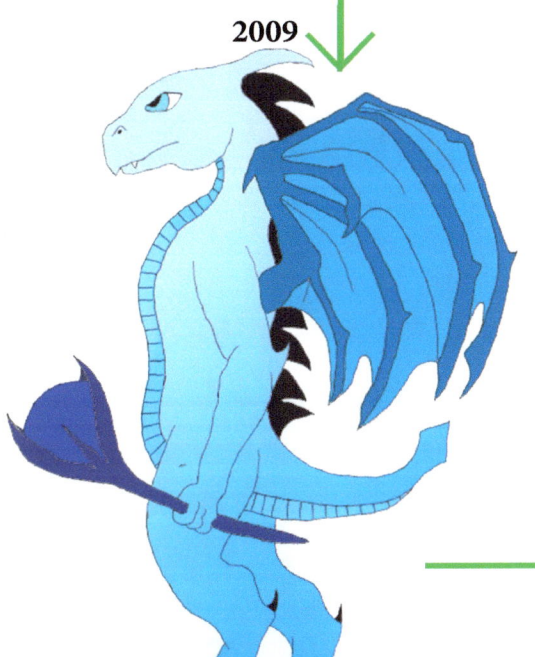

2014

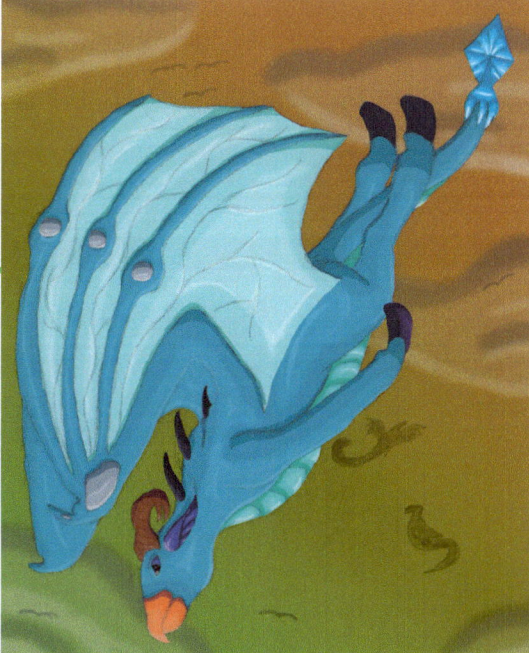

43

Hinkas Through the Ages

Reptile Hinka 2: Star Crested Dragons

Star Crested Dragons are a favorite hinka of mine. All of them have a "star" on their foreheads, hence the name. Otherwise they have a large variety of designs. As a child, I had the "star crested dragons" as a species but I also had a group of five dragons called the "star crested dragons" or S.C.D.s for short. I don't actually remember which came first. I made a drastic change for the adulthood versions—I based the new design on ostriches and emus (because most of these dragons have two legs and a pair of wings).

Childhood Versions

The bottom five are a group of the star crested dragons called the "SCDs." They don't represent all Star Crested Dragons but show a good variety of this species.

These "SCDs" don't actually have names. They are all just numbered: SCD #1, SCD #2, SCD #3, SCD #4, and SCD #5. The #1 is the strongest followed by #2. They go down in power in descending order. And they all have "real gold" and "real silver" on them.

SCD #1

SCD #2

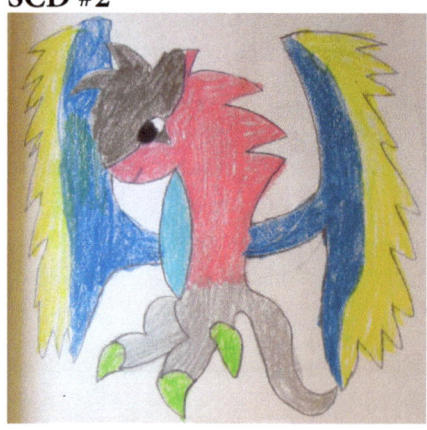

SCD #3

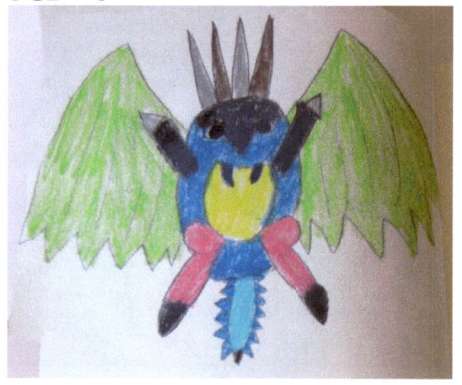

SCD #4

SCD #5

On the opposite page, there's a picture of a typical childhood era "star crested dragon" (not one of the five SCDs!). I found at least 100 different variations of the exact same pose.

Adulthood Versions

These are the "special colored" versions of a redone SCD. This time it's a species and not just a group of dragons. The bottom right picture is called "Star Crested Dragons."

Regular

Baby

Avalanche

Royalty

Firebird

Early 2000s → **2016**

Hinkas Through the Ages

Reptile Hinka 3: Knuexmoore

Knuexmoore (new-EX-moor) is a character that I loved drawing as a kid. I only drew one pose, basically, but I drew it many times! He played a small part in the stories I wrote as a kid, but I don't actually remember what he did.

This character was supposed to be a "bird" originally but I changed it to be a reptile because it matched a more reptilian design.

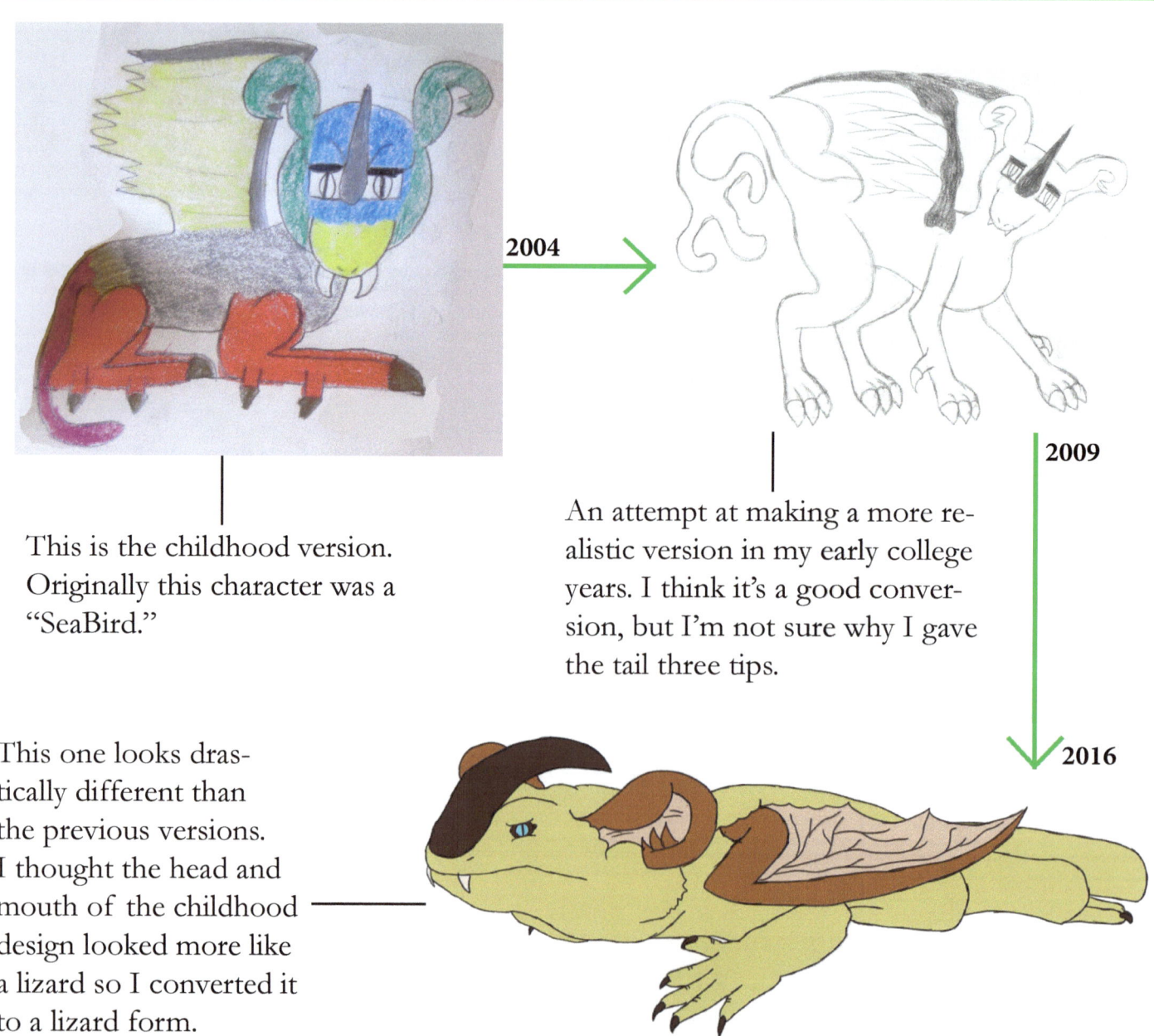

2004

This is the childhood version. Originally this character was a "SeaBird."

An attempt at making a more realistic version in my early college years. I think it's a good conversion, but I'm not sure why I gave the tail three tips.

2009

2016

This one looks drastically different than the previous versions. I thought the head and mouth of the childhood design looked more like a lizard so I converted it to a lizard form.

46

Reptile Hinka 4: Rinka/Rinkasaurus

Rinkasaurus was the original name for this character. He is supposedly a "spiked dinosaur." Most of the pictures I drew were black and white, but I love the rainbow look of the colored versions so I included those. I later changed his name to "Rinka" because it's easier to say. The adulthood version doesn't differ much because I couldn't figure out what type of animal this character should be based on. It's a "dinosaur" but which one would I use? That's something I could explore further in the future.

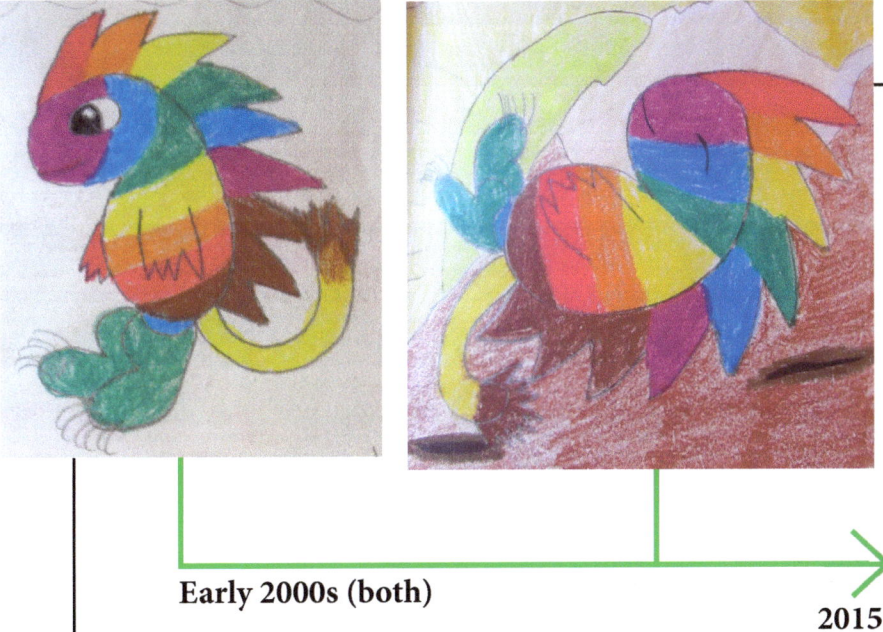

Early 2000s (both)

2015

This is a super cute version of Rinkasaurus. I didn't draw this pose as much. I also like the inclusion of the background.

This is a very standard pose for the childhood version of Rinkasaurus. I love all the rainbow colors!

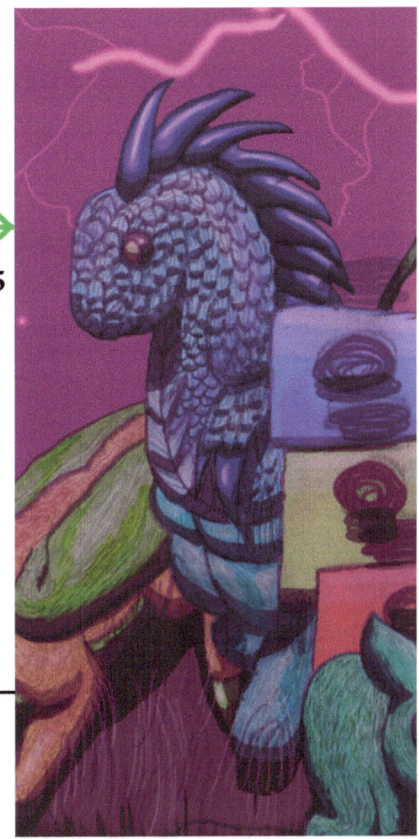

This is from a picture I drew called "Psydonvex (sigh-done-vex) Hill." I used a black and white version of Rinka to create this so that's why it's blue and not rainbow colored.

Hinkas Through the Ages

Reptile Hinka 5: Snahinka

Snahinka (snuh-HINKA) was a hinka that I liked a lot as a kid. It's a snake with stubby legs, cat ears (because I had an obsession with cats), frills, and spiny tail. The two childhood poses below are the only two poses I could find. I drew them so many times, though. I loved redesigning this hinka to be more realistic because there were several different textures: scales, fur, and frills. It ended up being a really cute snake.

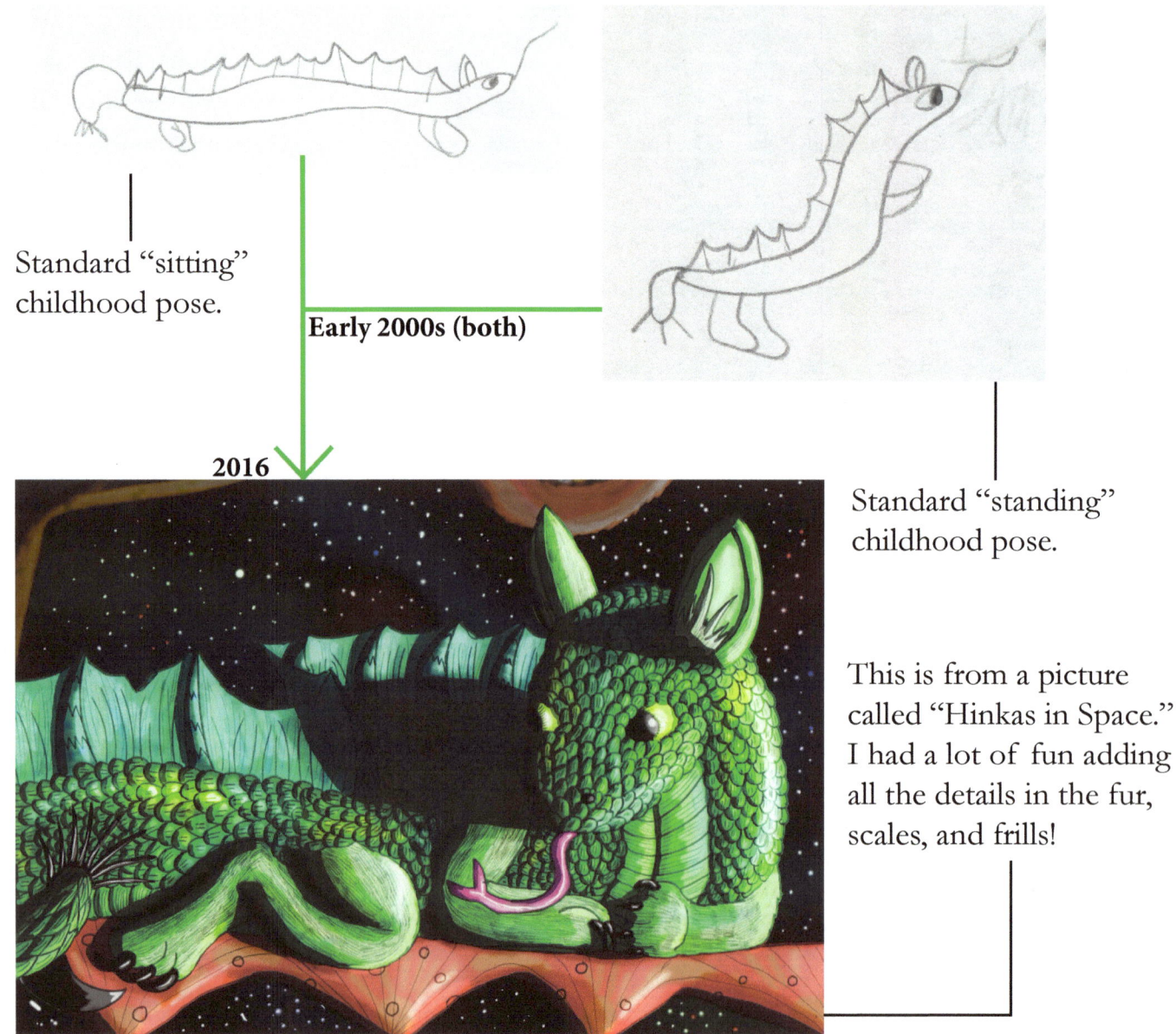

Standard "sitting" childhood pose.

Early 2000s (both)

2016

Standard "standing" childhood pose.

This is from a picture called "Hinkas in Space." I had a lot of fun adding all the details in the fur, scales, and frills!

Reptile Hinka 6: Snakia

Snakia (SNAKE-ee-uh) is related to snahinka but it has huge spikes on its back rather than frills. I'm not sure how this snake could get around easily or climb up trees with those huge spikes on its back, but I really liked drawing spikes as a kid.

I made the spikes large on the adulthood version but they didn't cover the entire back. This would give the snake a bit more flexibility in its movement.

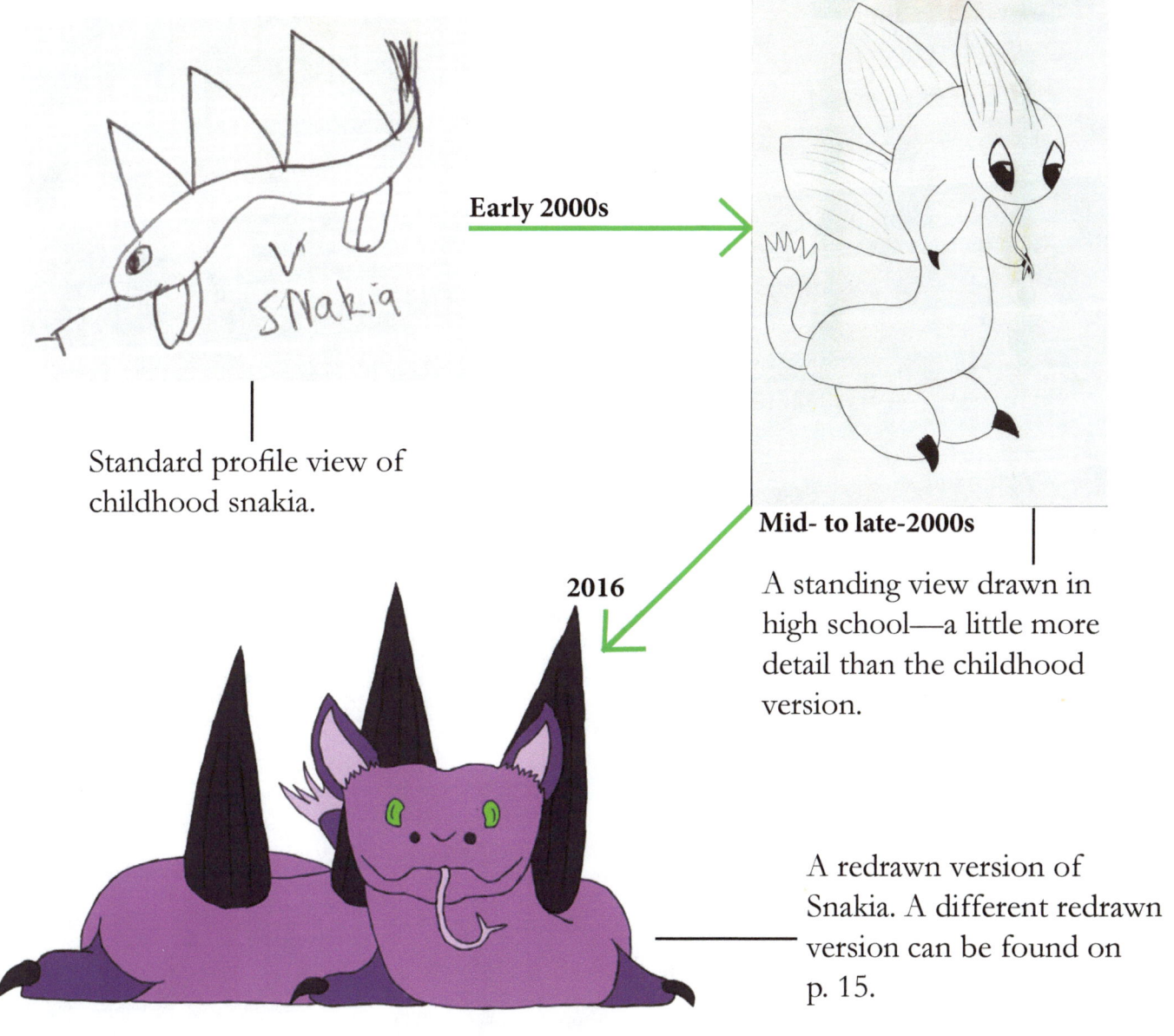

Standard profile view of childhood snakia.

Early 2000s

Mid- to late-2000s

A standing view drawn in high school—a little more detail than the childhood version.

2016

A redrawn version of Snakia. A different redrawn version can be found on p. 15.

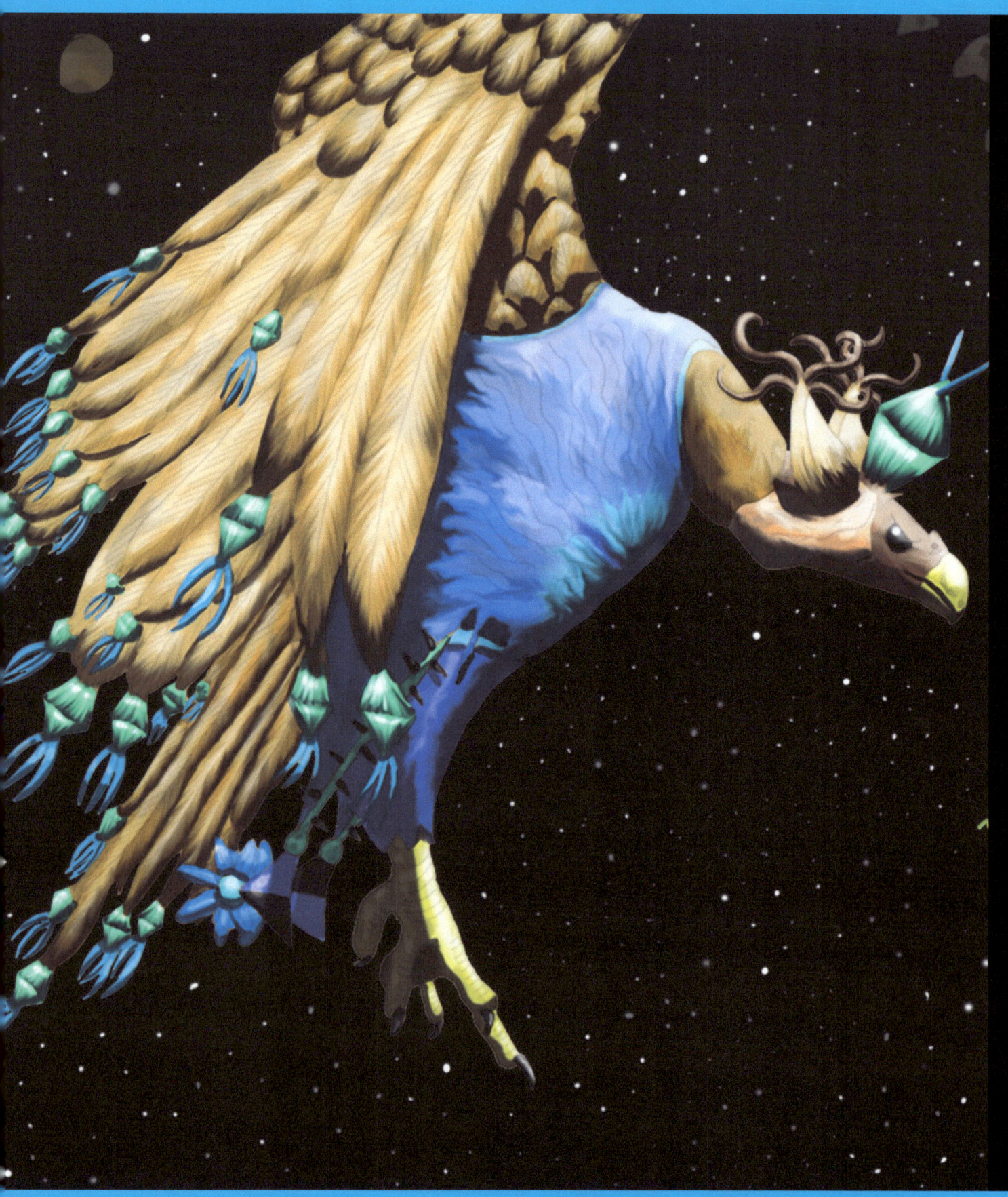

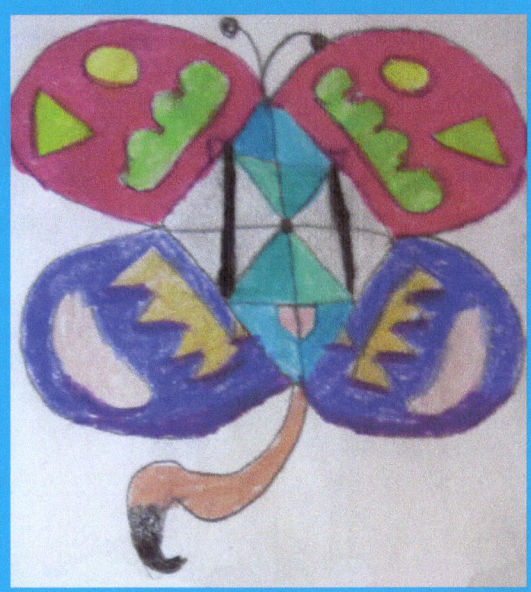

Chapter 4: Others

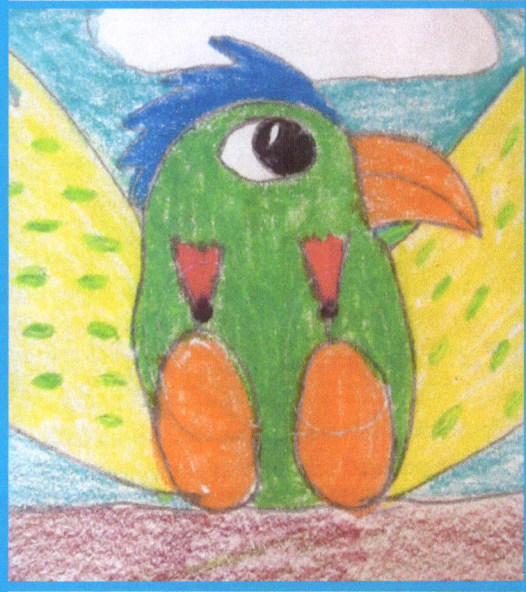

These hinkas include anything that didn't fit into the other chapters: birds, horses, insects, etc. I drew a lot of hinkas in these categories as a kid, but there weren't as many I redrew as an adult.

The cool thing about this category is it contains a variety of species which I had to figure out how to draw. For a section like cats, once you figure out the basic shapes of a cat it's easy enough to draw a large variety of felines. But if you're dealing with very different shapes--especially when it comes to insects and other arthropods--that presents a cool drawing challenge.

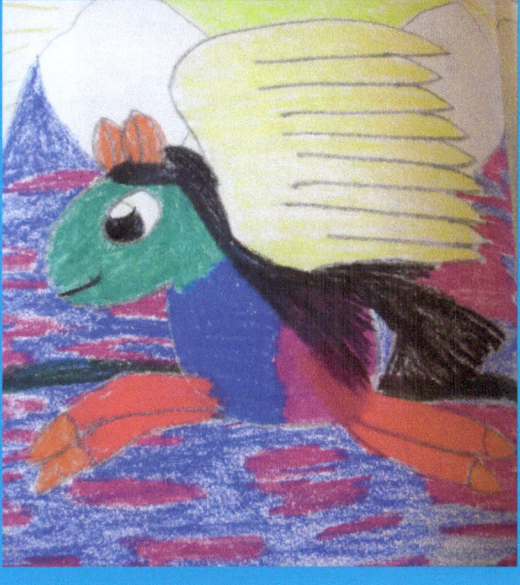

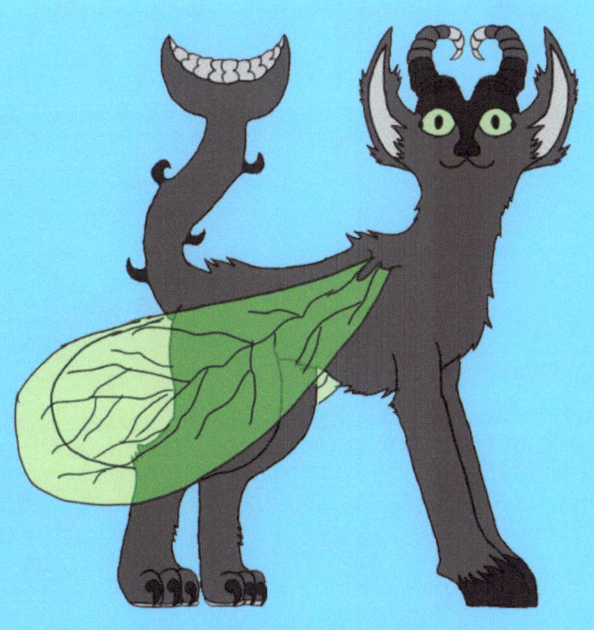

51

Other Hinka 1: Crystal

Crysutterfly (Chris-utter-fly) was the original name of this character. She's a "crystal butterfly" whose design was changed many times over the years (she's my character with the most versions drawn). I later changed her name to Crystal because Crysutterfly is really long and, even though it sounds neat, it's a lot easier to just say "crystal."

Now she's "Crystal the crystal butterfly." Kind of like "Hinka the hinka."

Childhood Versions

I drew a lot of different variations of Crysutterfly and crystal butterflies during my childhood. Here are a few of the best examples I could find.

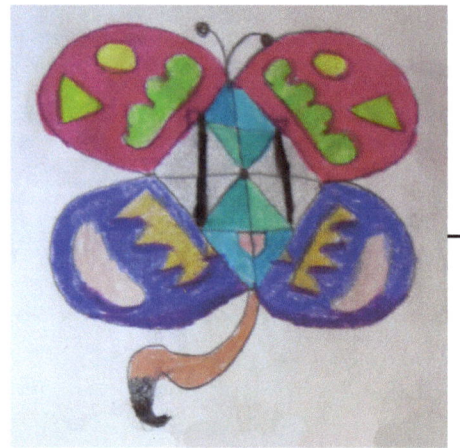

One version of Crysutterfly with a "crystal" body. The eyes take up the right and left sides of the "crystal" and she has a tail!

Another version of Crysutterfly with a "crystal" body. Her eyes are on the top of the crystal!

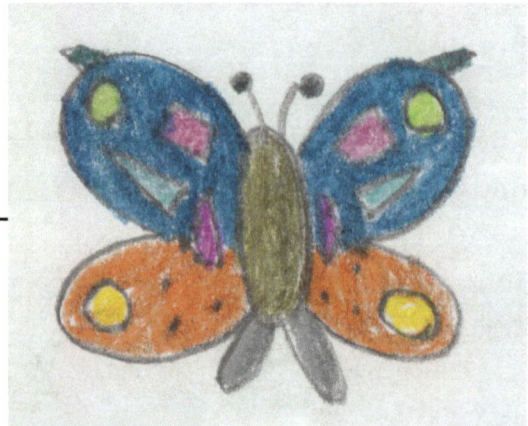

A version of Crysutterfly with a "normal" butterfly body. It almost looks like those gray appendages at the bottom are thick legs.

Other Hinkas

High School Versions

I didn't draw Crysutterfly that much in high school. These new designs are pretty cool, but it's amazing how different they are even during this era!

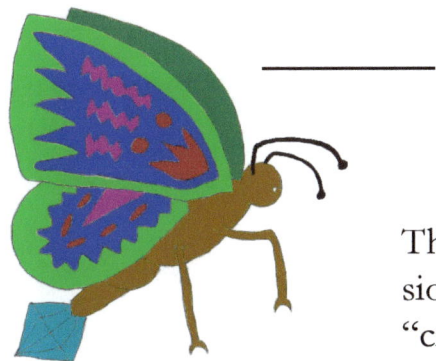

I didn't realize that butterflies had six legs at the time I drew this.

This is a very fancy version of Crysutterfly. The "crystal" body is back!

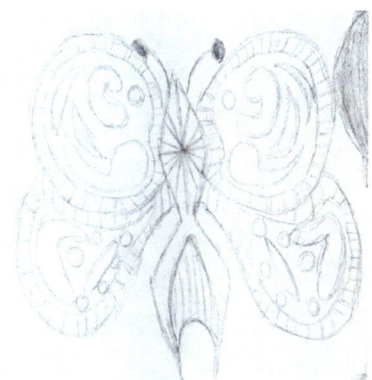

Adulthood Versions

I got a better handle on insect anatomy as an adult. It still took me a few tries to actually get a working design down for Crystal (at this point that was her name).

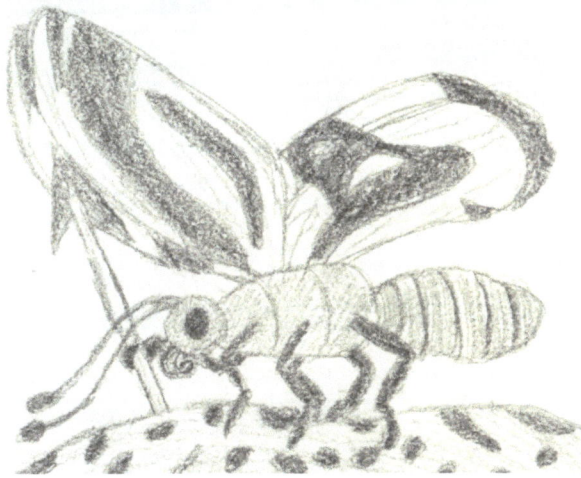

This is a more realistic-looking butterfly with three body parts and six legs and actual butterfly mouth parts. I like the wing designs and the way this one was shaded.

A colored version of the more realistic version of Crysutterfly. The designs on this one are different than the one above but it does look cool having colors!

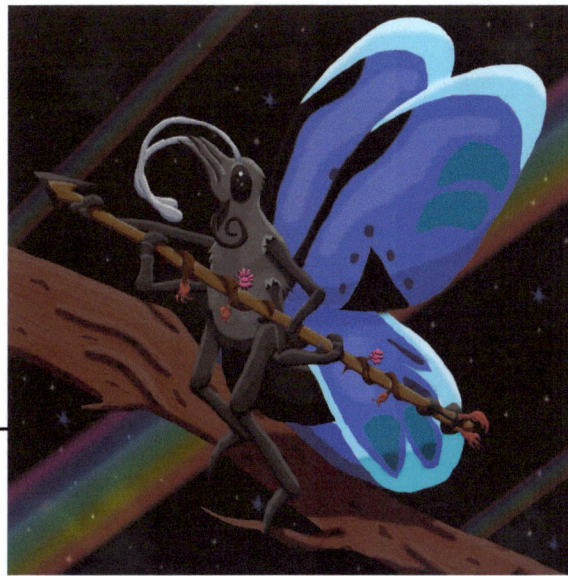

53

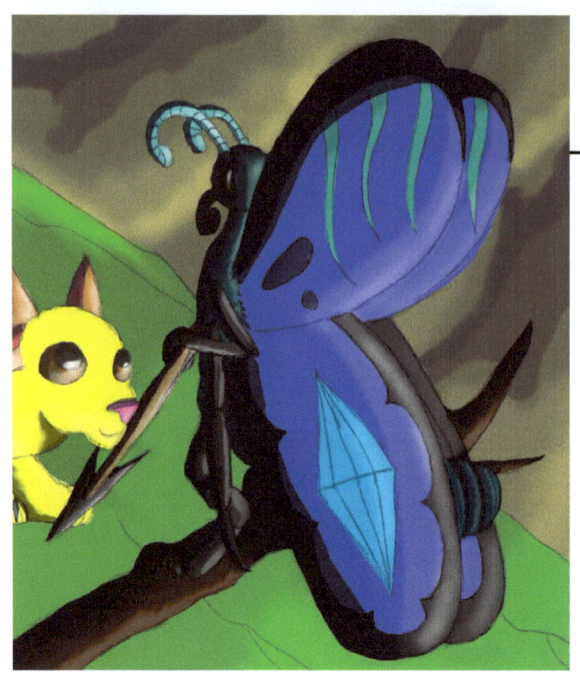

This is a cool back view of Crystal. At this point I tried to actually establish her final design.

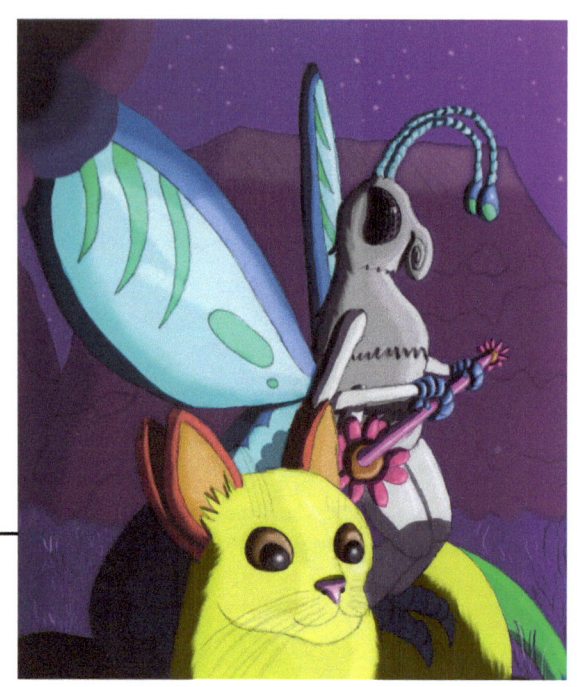

My most recent version of Crystal in the picture "Hinka and his Buddies" (see title page). This one actually has the same design as the one above! Wow! But the colors are different. And the spear is super flowery this time.

~~~~~~~~~~~~~~~~~~~~~~~~~~~~~~~~~~~~~~~~~~~~~~~~~~~~~~~~~

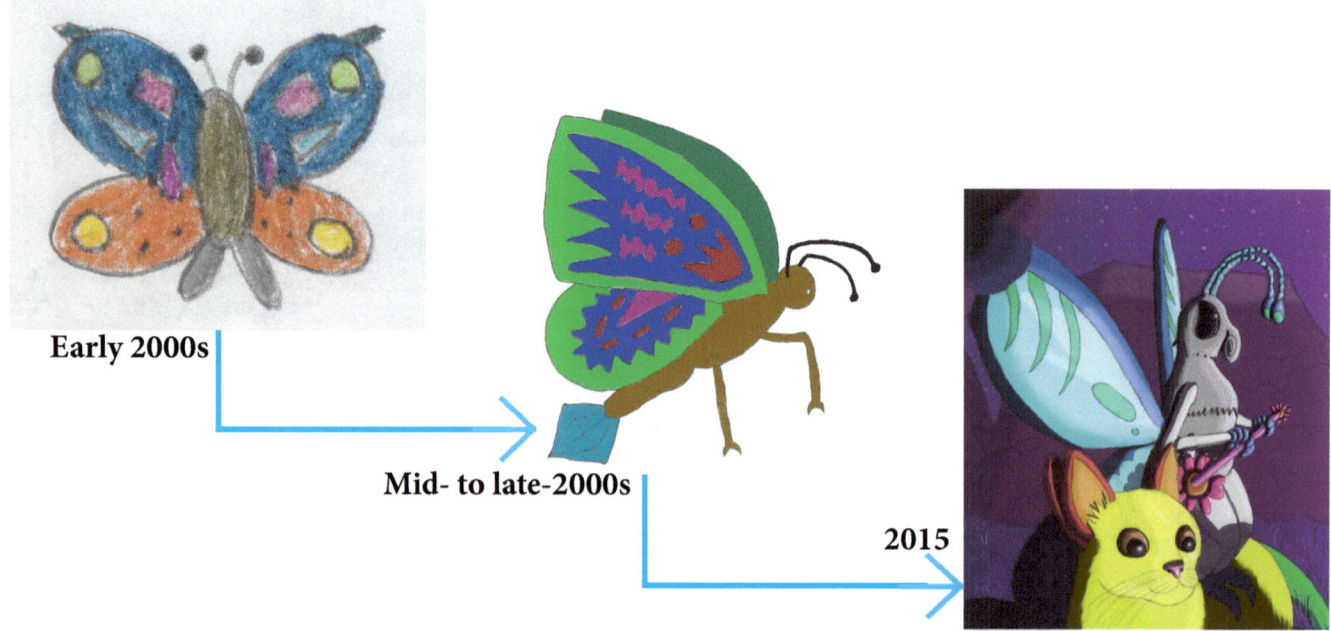

**Early 2000s**

**Mid- to late-2000s**

**2015**

# Other Hinka 2: Koo Woo Bird

Koo Woo Birds were my favorite bird hinkas to draw as a kid. I drew the same poses over and over and over again. The large claws on their feet are supposed to be strong enough to allow them to climb cliffs because they can't actually fly. And their tiny little arms have balls at their tips which can blow out air and help the Koo Woo Birds jump higher. For some reason, I actually seemed to think about the anatomy and getting these hinkas to operate realistically. That's something I rarely did as a child.

## Childhood Versions

These are the best examples of koo woo birds because they have cool colors. This color design belongs to one of my koo woo bird characters, Char Char (Koo Woo).

Standard childhood standing pose.

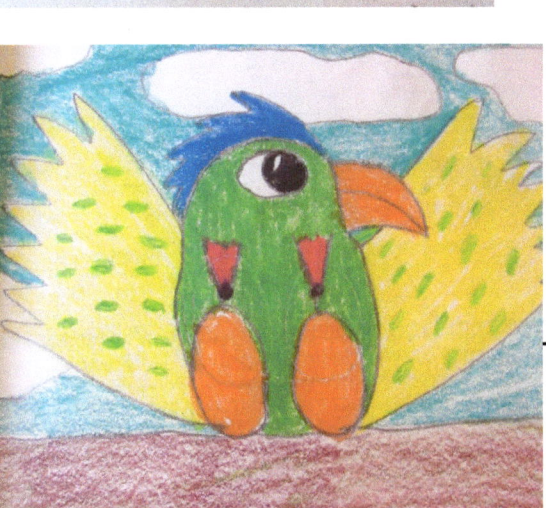

A cute front-view sitting pose.

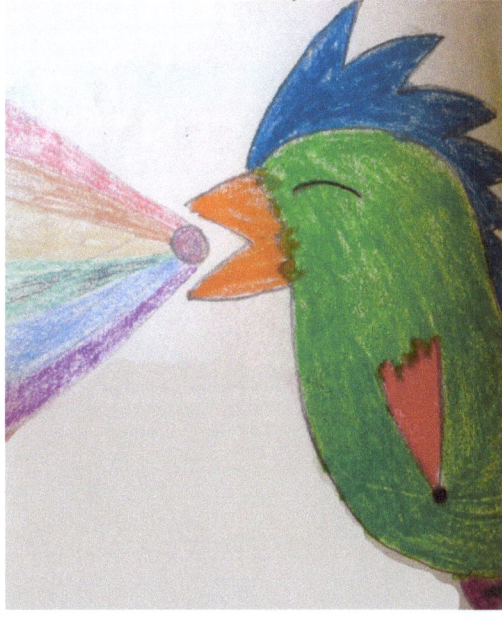

Char Char breathing an "energy ball" in his beak.

## High School Versions

I only found two of these three-quarters views for the koo woo bird but I'm pretty sure I drew more of them. I liked trying to figure how they would express different emotions!

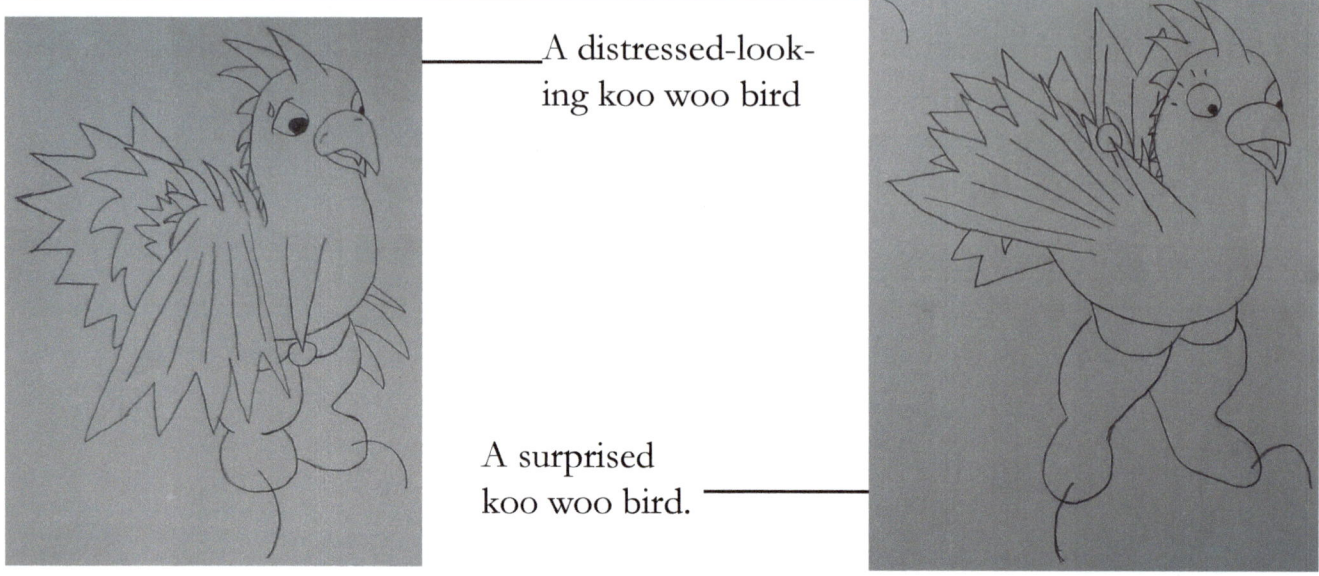

A distressed-looking koo woo bird

A surprised koo woo bird.

## Adulthood Versions

Even though I put some effort into designing a species that could sort of work in real life as a kid, I ended up changing the design drastically as an adult.

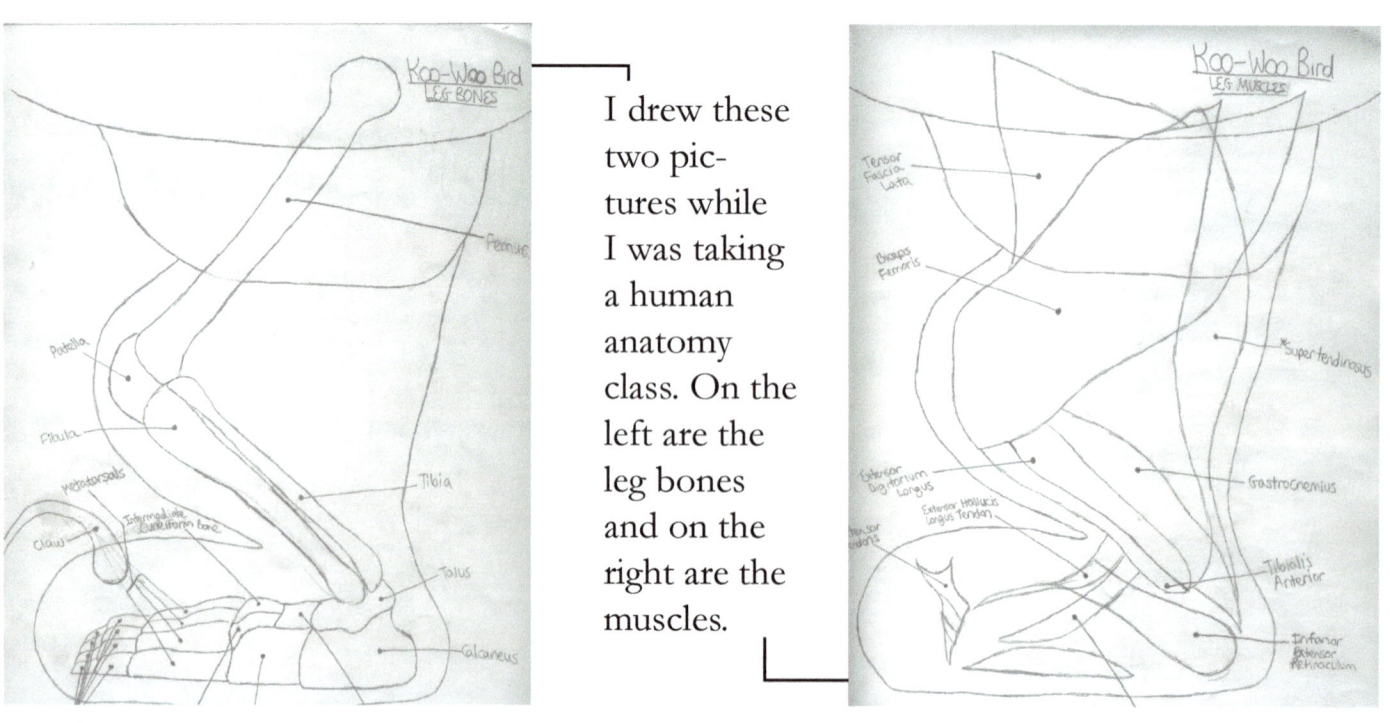

I drew these two pictures while I was taking a human anatomy class. On the left are the leg bones and on the right are the muscles.

*Other Hinkas*

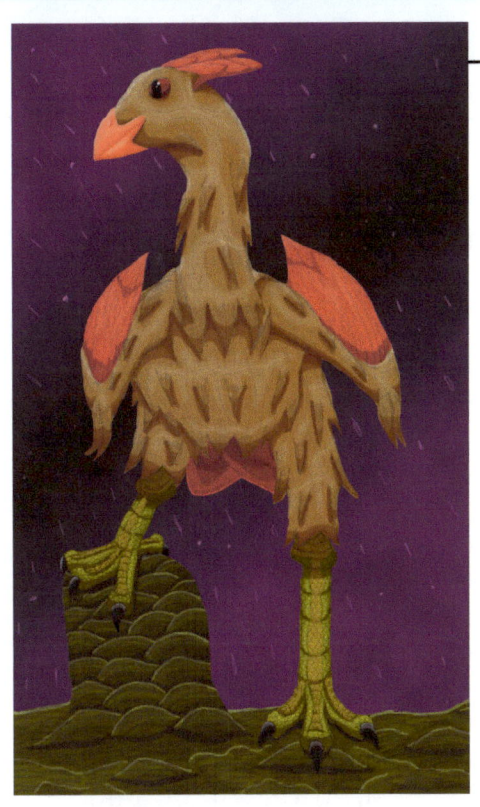

One version of a koo woo bird drawn in 2013. I wanted to make it look more realistic so I changed the legs to be normal bird legs.

A redrawn version of a koo woo bird. I based this on a ratite.

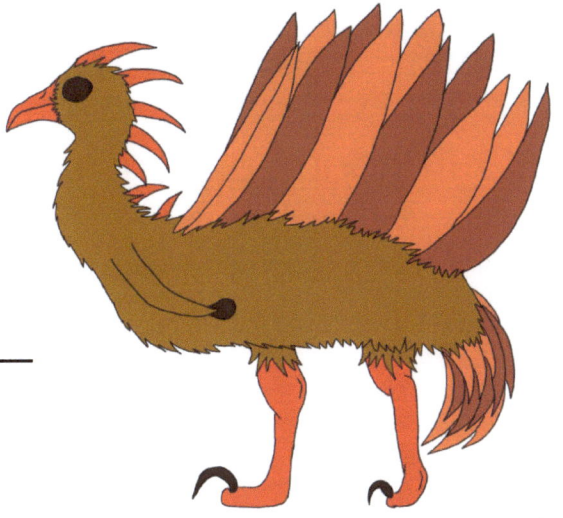

**Early 2000s**

**Mid-to-late 2000s**

**2016**

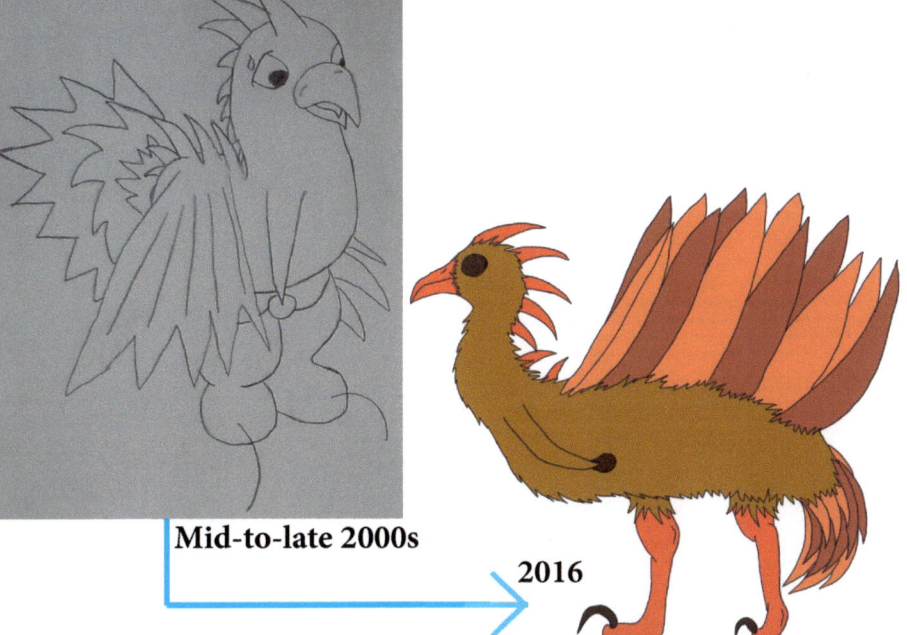

Hinkas Through the Ages

# Other Hinka 3: Pegasi

I didn't draw that many horses as a kid. In fact the only ones I really drew were pegasi and so-called "rocket horses" (see p. 60). I especially liked drawing one pegasus character of mine, Dimera. I also had other pegasi characters such as the Pegapatrol.

## Childhood Versions

These are some examples of how I drew pegasi as a kid. They're awfully cute with those giant heads, but I do question some of the leg anatomy.

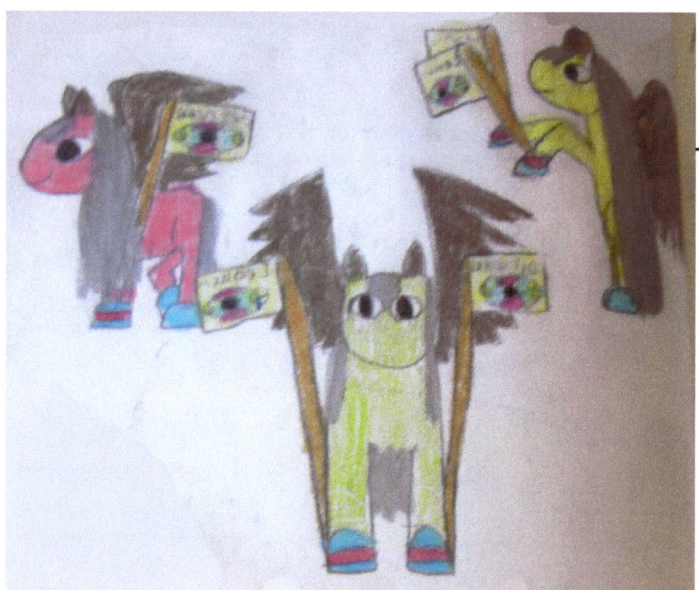

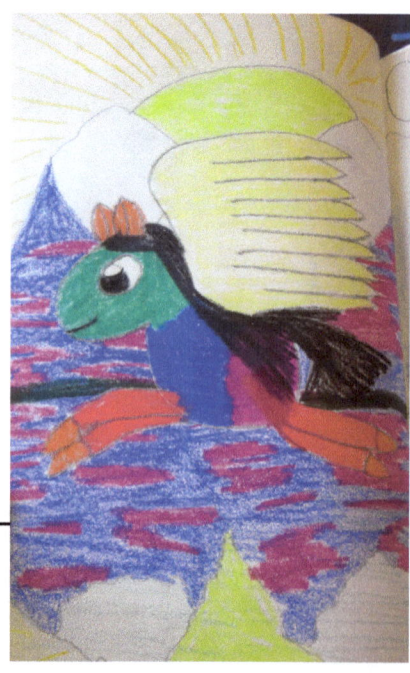

This is the "Pegapatrol," a group of Pegasi who roam around the forest they live in, Leaux (loo) Forest, looking for hinkas who need help. See p. 35 for another hinka from Leaux, Squire Ella.

A flying version of Dimera the pegasus. It's a bit hard to see her because the background colors are similar. But it's neat to see a picture with a background!

*Other Hinkas*

## High School Versions

I'm sure I drew more than one picture like this during high school, but this was the only one I could find.

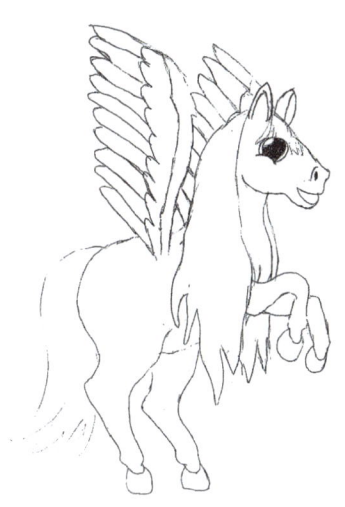

This was the only drawing I could find that looked different than the childhood versions. I ——— had a better handle on anatomy at this point.

## Adulthood Versions

I've drawn very few horses as an adult. I may consider drawing more in the future.

This version has decent anatomy, though the legs don't look quite right. It does convey action with the wings spread out, though!

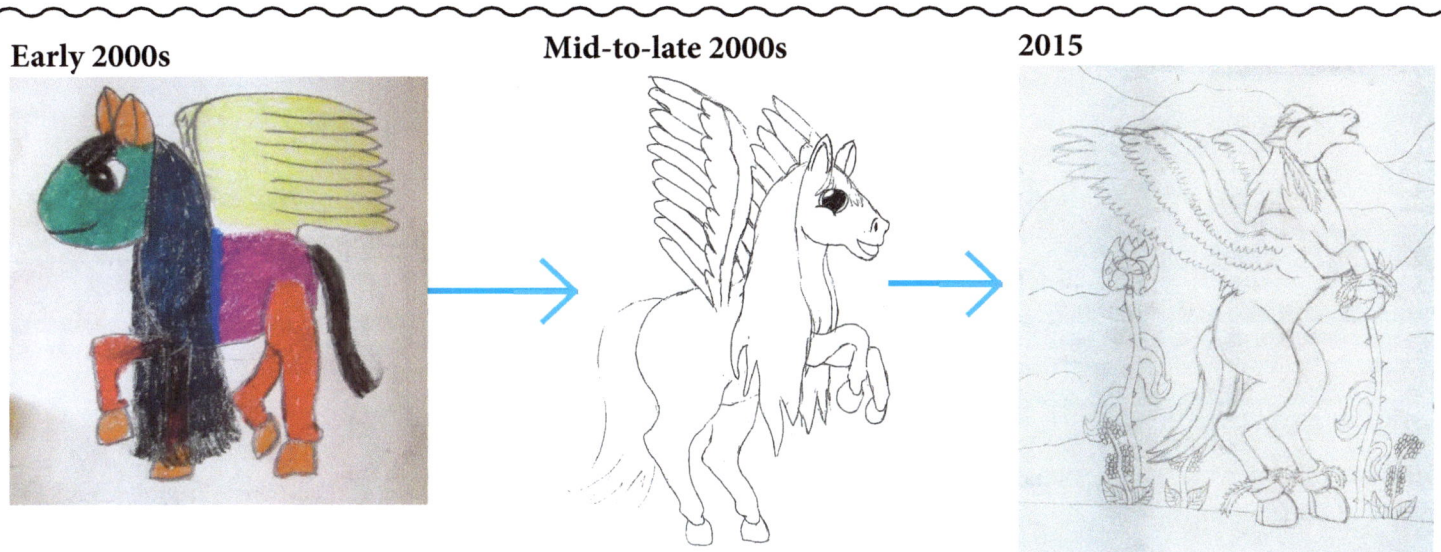

**Early 2000s**  **Mid-to-late 2000s**  **2015**

*Hinkas Through the Ages*

# Other Hinka 4: Edicaida I

Edicaida I (ed-ih-KAI-duh the first) the first was one of the "bad" guys in a story I wrote when I was 13 (a story titled "Edicaida I and Sytupherious" - Sytupherious (sigh-two-fair-ee-us) was Edicaida's partner in crime). Originally he was a pegasus but later I changed his design to that of a "rocket horse," a horse that has wings which have "rockets" on them that propel the horse forward. "Edicaida I and Sytupherious" inspired a "publishing company" I also made up as a kid (see p. 24).

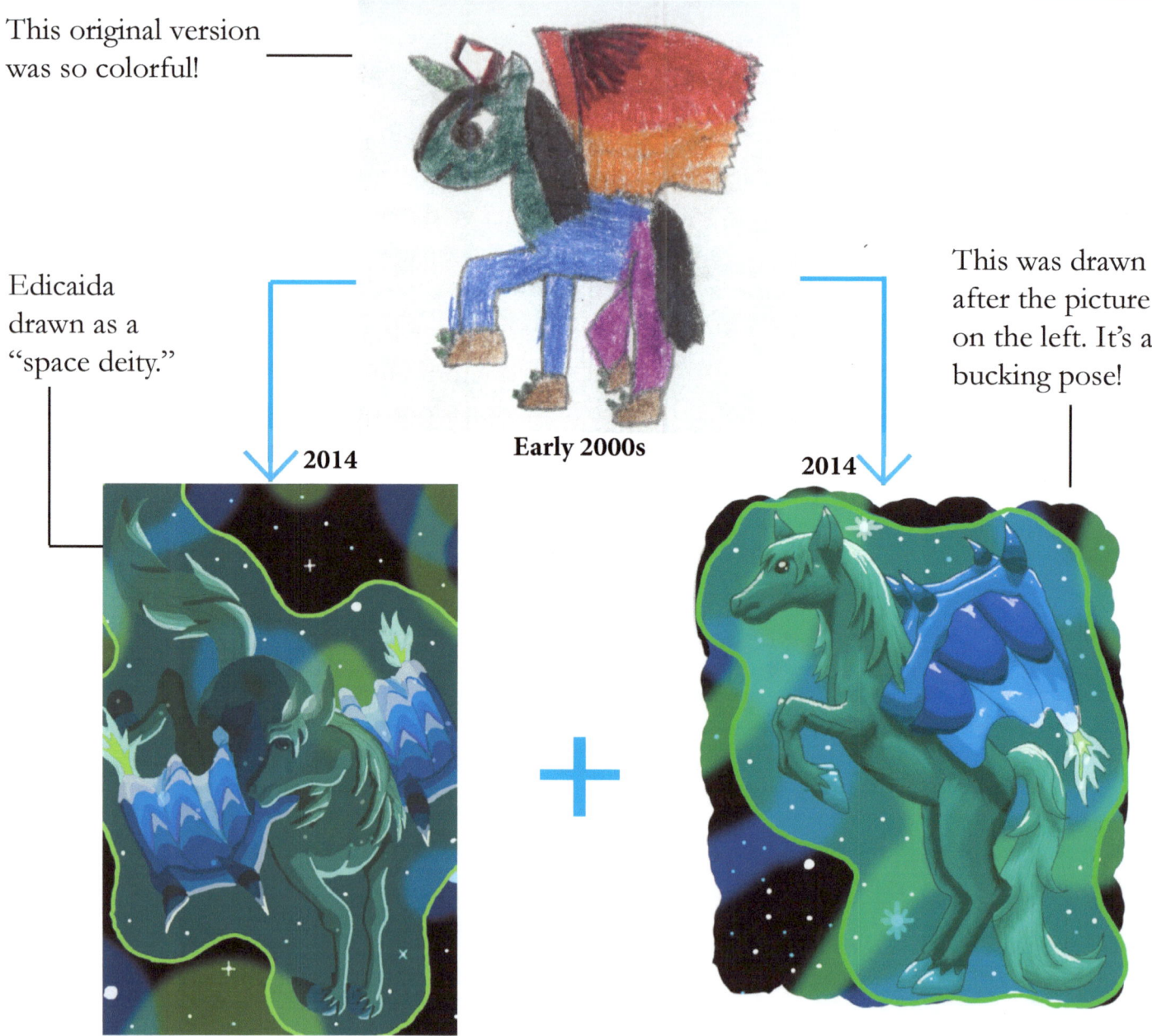

This original version was so colorful!

Edicaida drawn as a "space deity."

**2014**

**Early 2000s**

**2014**

This was drawn after the picture on the left. It's a bucking pose!

60

# Other Hinka 5: Kapamuriatei

Sometimes for the longer hinka names I gave pronunciation guides which was really nice. When I drew this picture, I gave this name a pronunciation of "cap-uh-mariety" (I wrote "variety" as a kid and crossed out the "v" to put an "m"). When I recently saw the word, I thought it would be pronounced as "cap-uh-myur-ee-ay-tay." Both ways to pronounce it are cool (or ridiculous, depending on how you view it).

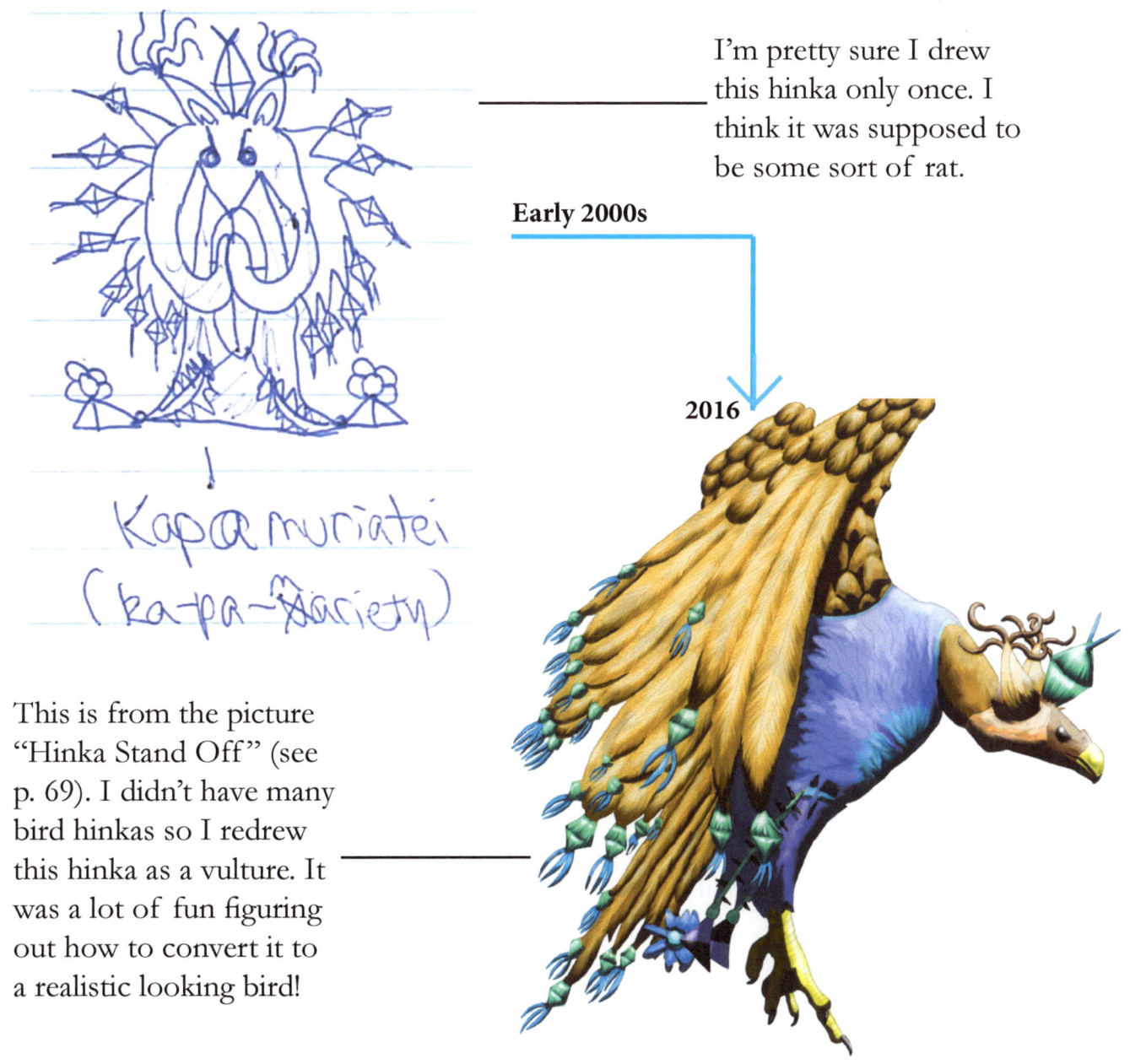

I'm pretty sure I drew this hinka only once. I think it was supposed to be some sort of rat.

**Early 2000s**

**2016**

This is from the picture "Hinka Stand Off" (see p. 69). I didn't have many bird hinkas so I redrew this hinka as a vulture. It was a lot of fun figuring out how to convert it to a realistic looking bird!

*Hinkas Through the Ages*

# Other Hinka 6: Miracowew

Miracowew (MEER-uh-cow-ew), or Mira, is a "sphere bat." He is the deity of "creature magic" on the planet the hinkas reside on, Poiuyt (pronounced as pout). Creature magic refers to magic that allows hinkas to shapeshift into other forms. Miracowew is also able to breathe what is called "galaxy breath." And he is insanely fast.

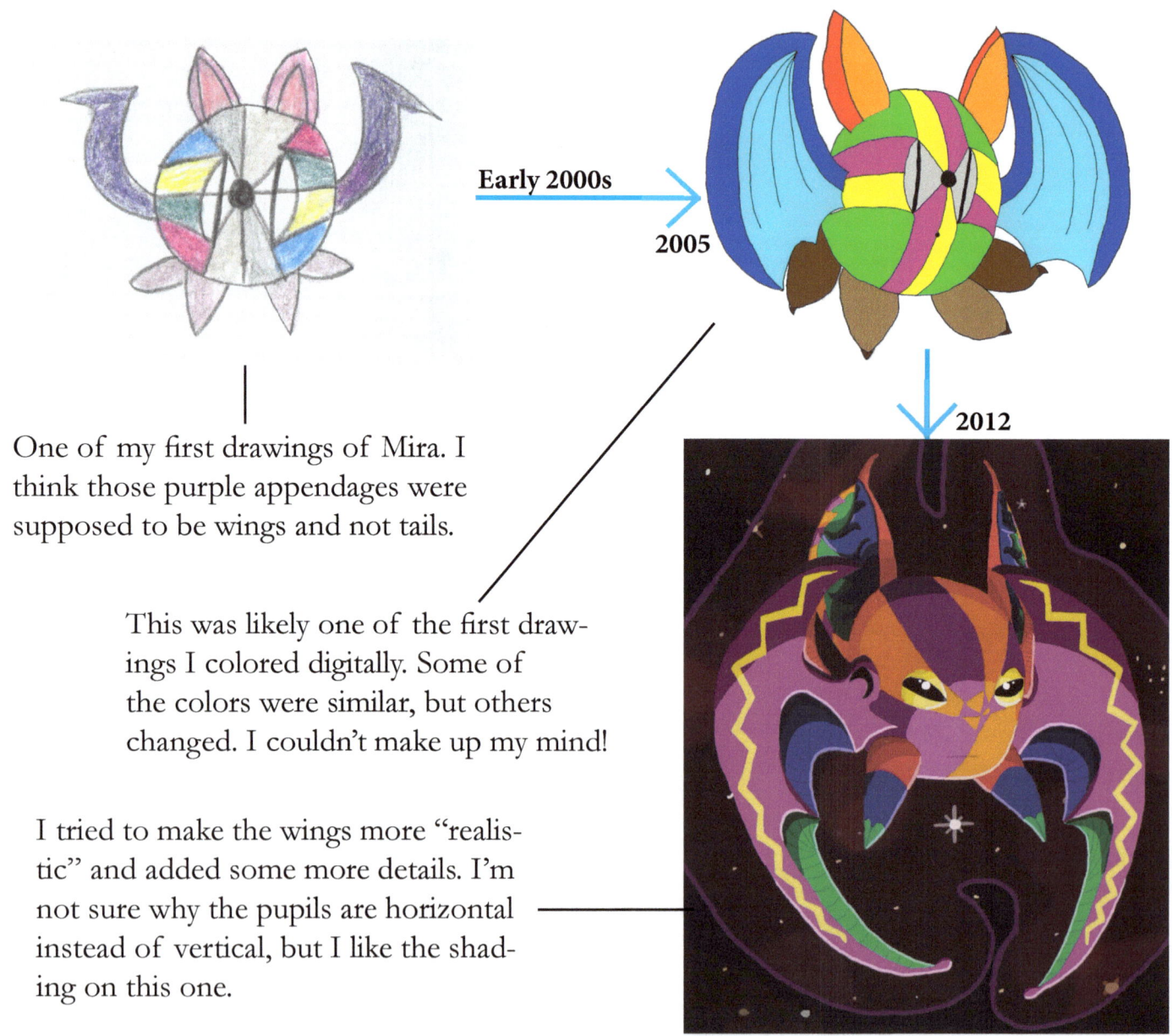

One of my first drawings of Mira. I think those purple appendages were supposed to be wings and not tails.

This was likely one of the first drawings I colored digitally. Some of the colors were similar, but others changed. I couldn't make up my mind!

I tried to make the wings more "realistic" and added some more details. I'm not sure why the pupils are horizontal instead of vertical, but I like the shading on this one.

# Other Hinka 7: Kangaduo

This was a hinka I drew only a few times. I think the design is pretty cool, but I guess I wasn't very enthralled by it as a child?

I added wings to this hinka because I liked to add wings to a lot of creatures when I was a kid. I always thought they made my hinkas look super cool, even if they are too small for the hinka to actually fly with them.

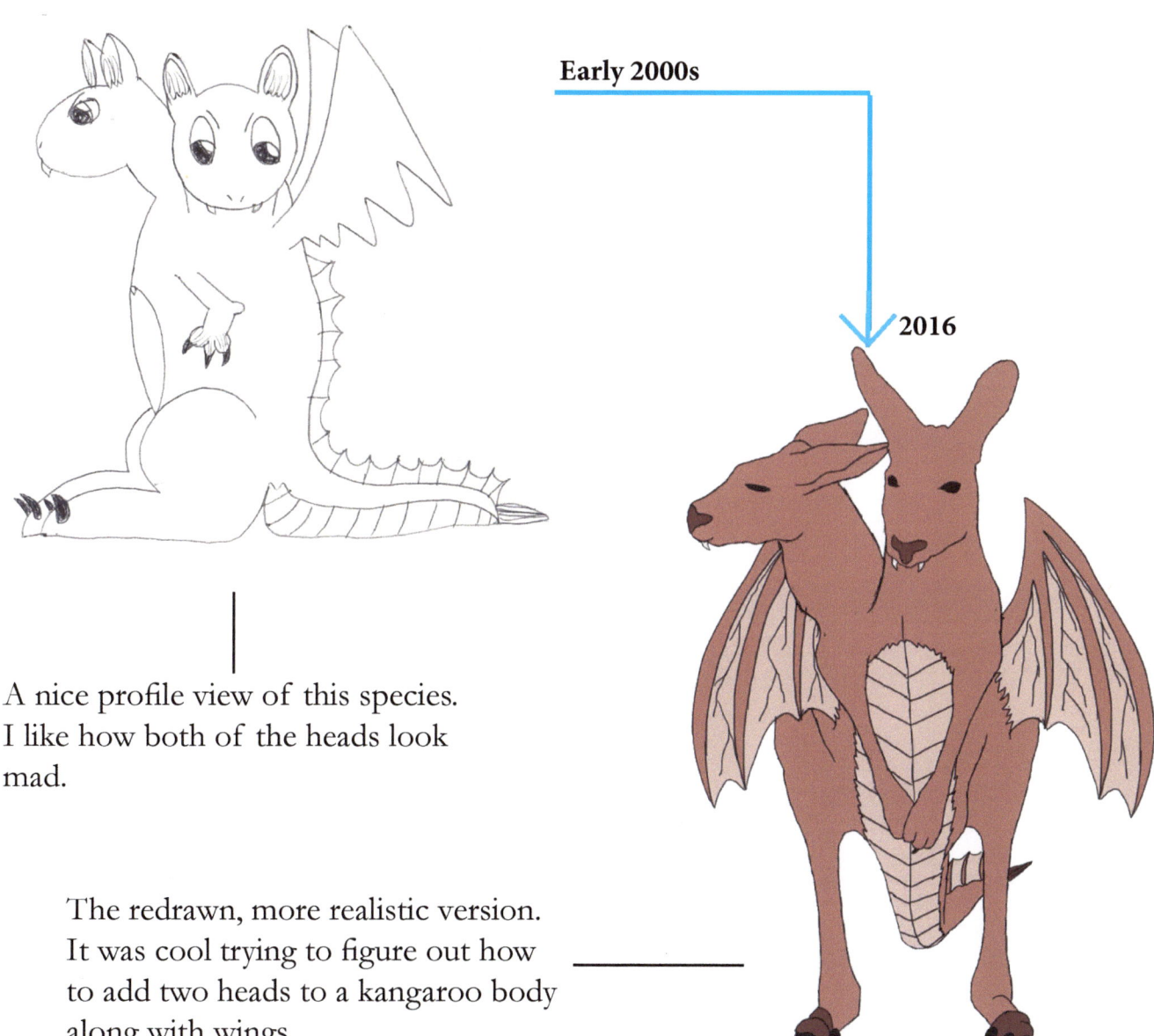

**Early 2000s**

2016

A nice profile view of this species. I like how both of the heads look mad.

The redrawn, more realistic version. It was cool trying to figure out how to add two heads to a kangaroo body along with wings.

## Other Hinka 8: Hooved Frog

I have no information on this particular hinka. I only drew it once and didn't actually give it a name. But I really liked the design so I decided to redraw it as an adult.

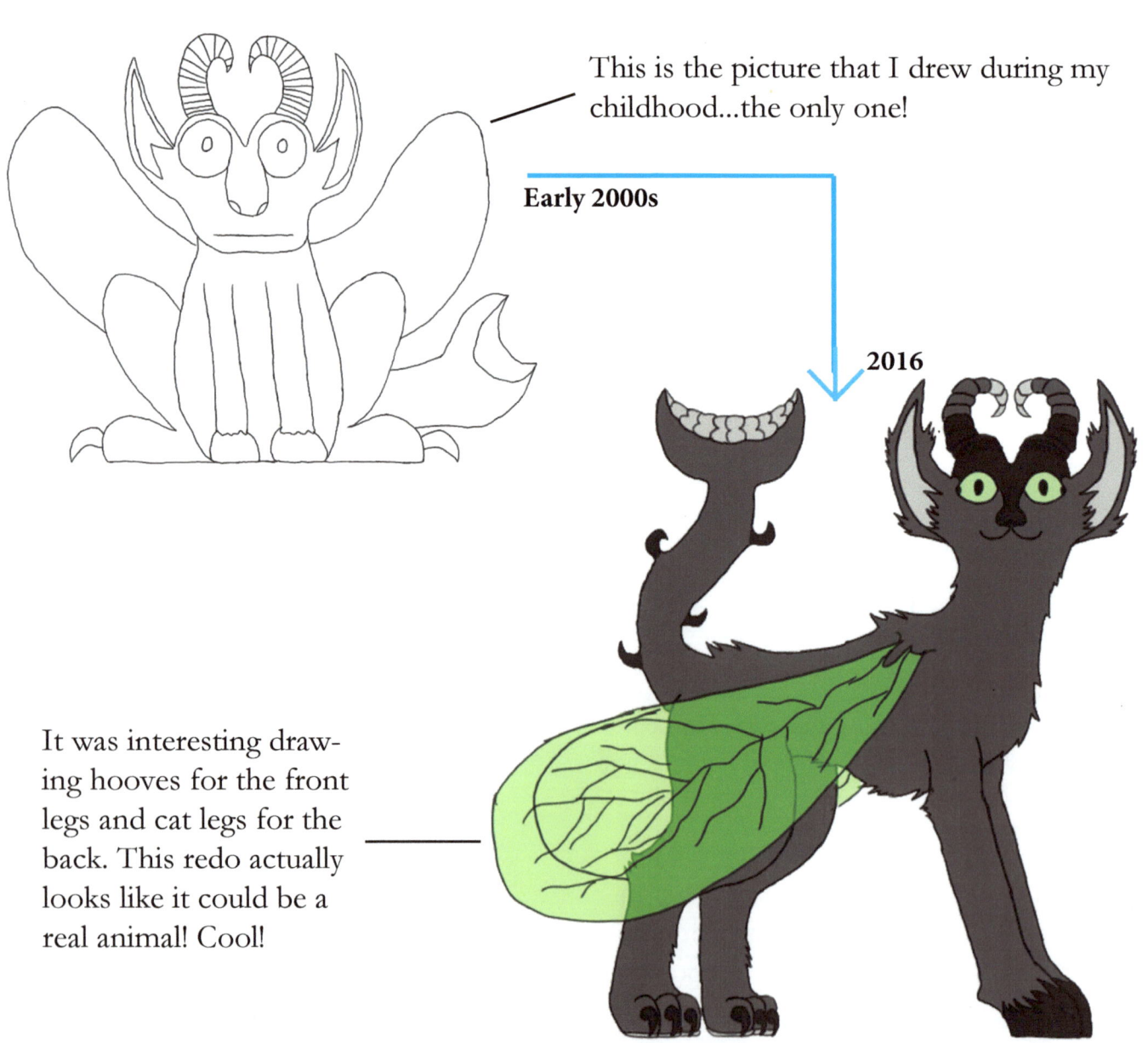

This is the picture that I drew during my childhood...the only one!

**Early 2000s**

**2016**

It was interesting drawing hooves for the front legs and cat legs for the back. This redo actually looks like it could be a real animal! Cool!

*Conclusion*

## A few examples of childhood hinkas not redrawn yet.

### Meeky, a cat hinka

### Bijoux, a "groundhog" hinka

### An unnamed sea hinka

### An unnamed sea hinka
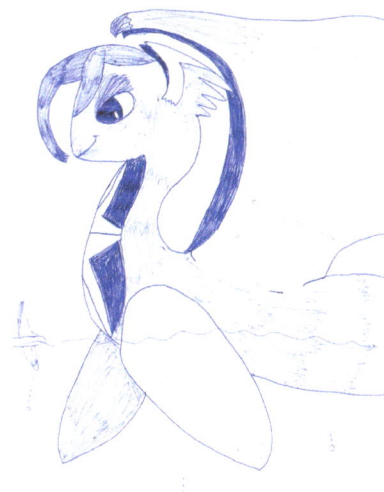

### Bhasg, a four-eared cat hinka
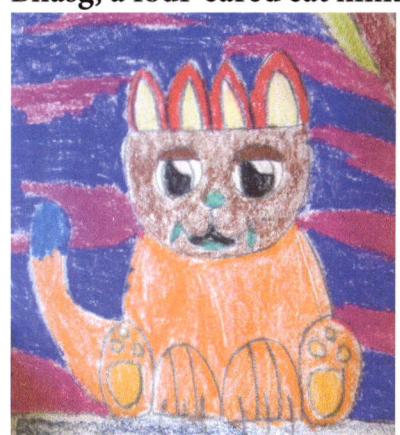

### Kokefreesh, unknown hinka type
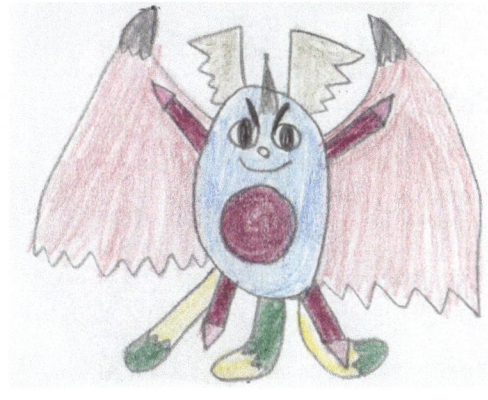

### Secnachu, a triangle cat hinka
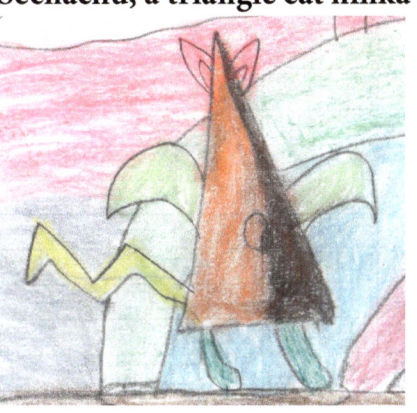

### Boynester, a bird hinka
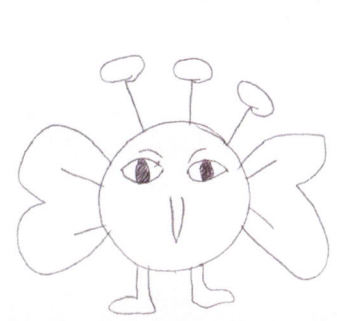

### Dragonteek, a dragon hinka
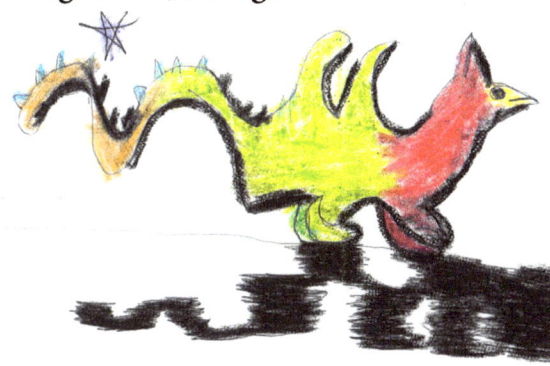

# Index

## A
Anthro Cats  20

## B
Bhasg  67
Bijoux  67
Boltcoon  26
Boynester  67
Broledee  36

## C
Char Char  55
Char Char Koo Woo  55
Creainka  14, 28
Crystal  12, 52
Crysutterfly  52

## D
Dragonteek  67

## E
Edicaida  24, 60

## F
Firecoon  26

## G
Gata  7, 70
Grelerod  36

## H
Hankia  31
Heneka  18
Hinka and his Buddies  1, 12, 28, 54
Hinkas in Space  18, 48
Hinka Stand Off  16, 61, 69
Hinka the Rainbow Cat  8, 54
Hooved Dragons  40
Hooved Frog  64

## I
Icecoon  26

## K
Kangaduo  63
Kapamuriatei  61
Kikacoons  15, 24
Kitticloud  19
Knuexmoore  46
Kokefreesh  67
Koo Woo Bird  55

## M
Meeky  67
Miracowew  62
Monkence  65

## P
Pegapatrol  58
Pegasus  58
Poiuyt  4, 17, 62
Psydonvex Hill  28, 31, 47

# Index

## Q
Quemo 32

## R
Repapkoobeton 17, 35
Rinatues 37
Rinka 47
Rinkasaurus 47

## S
Sansirama 40, 42
S.C.D.s 44
Secnachu 67
Snahinka 48
Snakia 15, 49
Special colored 45
Squire Ella 35
Star Crested Dragon 44
Sytuperhious 24
Sytupherious 60

## T
Tornacane 29

## W
Wave Creainka 16

## Z
Zoquem 32

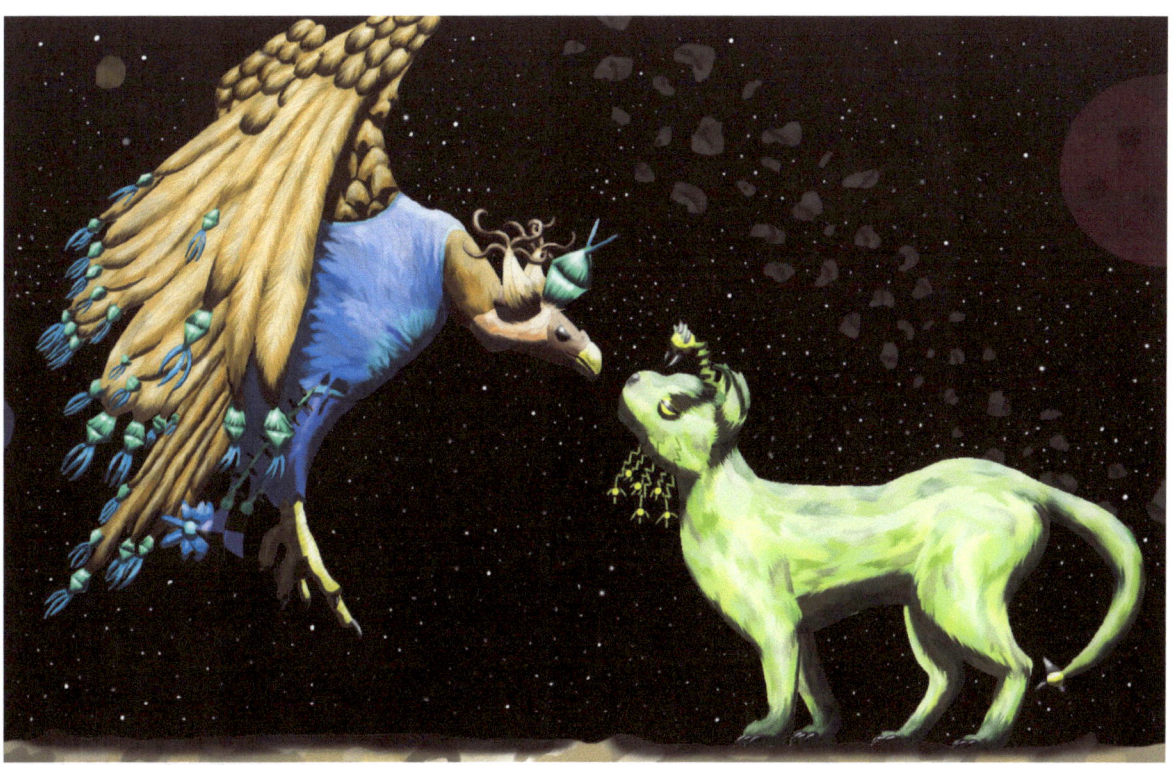

*Hinka Stand Off - 2016*

# About the Artist

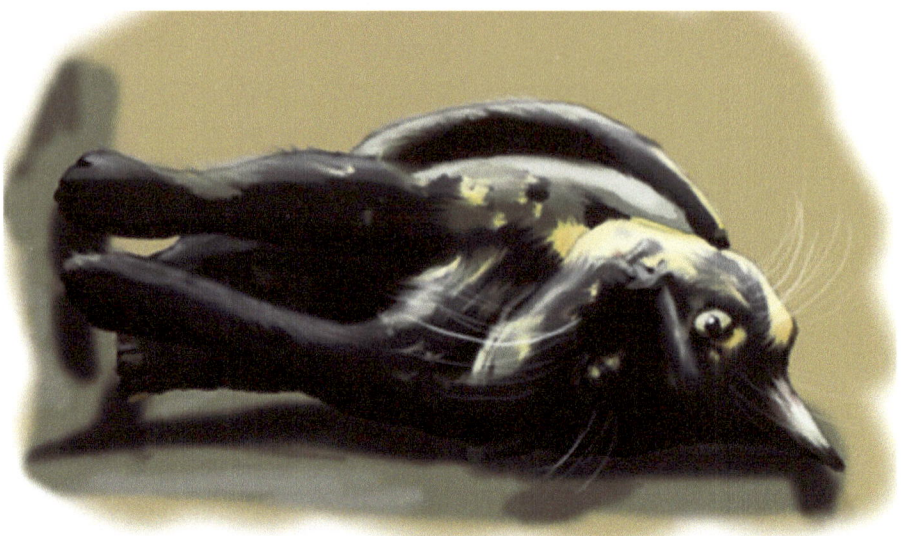

*My Cat "Gata" - 2015 (See p. 7 for a photo)*

Karen Roop is a fantasy artist. She and her sister, Catherine Roop, sell prints together at art shows and conventions. For more examples of their artwork, visit:

www.aliensoflactopia.com
www.catherineroop.com

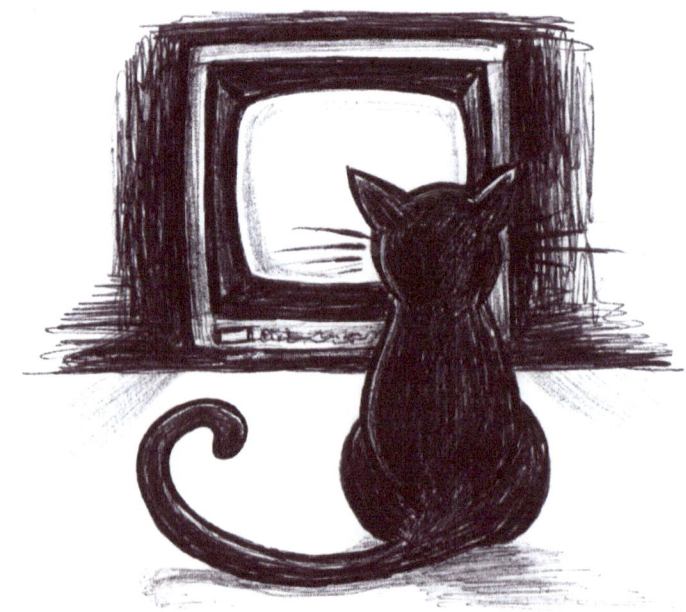

*Kitten TV (2014) by Catherine Roop*

# Examples of My Non-Hinka Artwork

**Most of the artwork I've been sending to conventions from 2015 to 2017 are not hinka related. Here are a few examples of them. Check out my website to see more!**

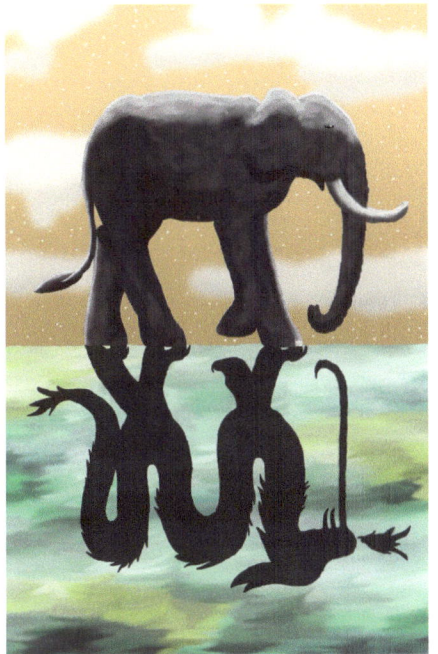
*Eastern Dragon Shadow - 2017*

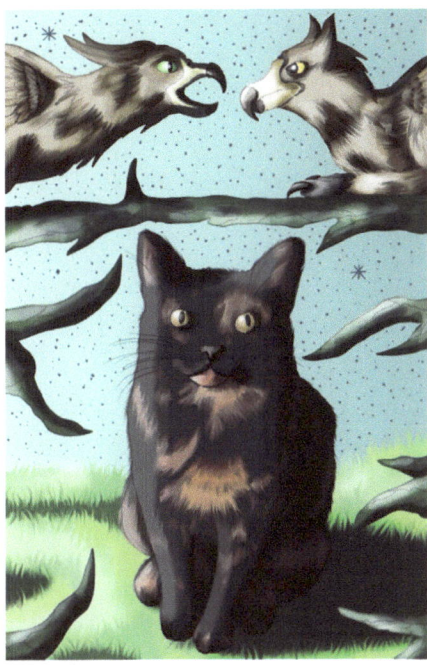
*Watching - 2017*

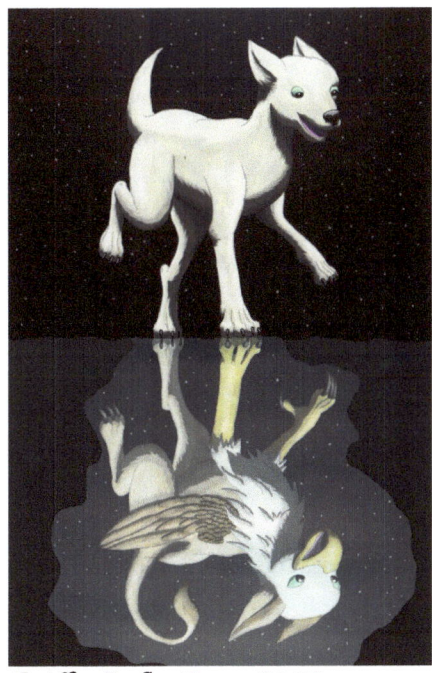
*Griffin Reflection - 2017*

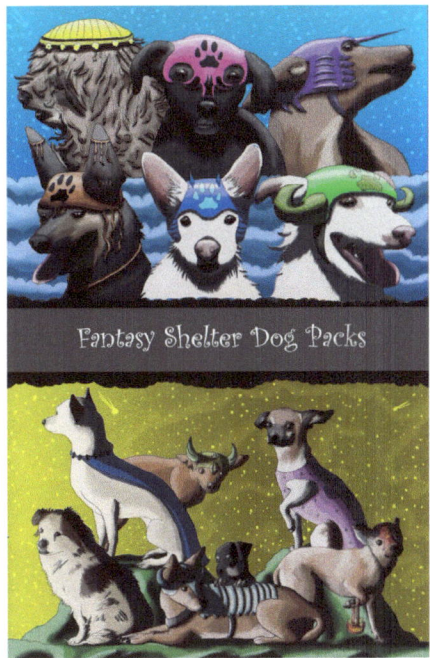
*Fantasy Packs - 2016*

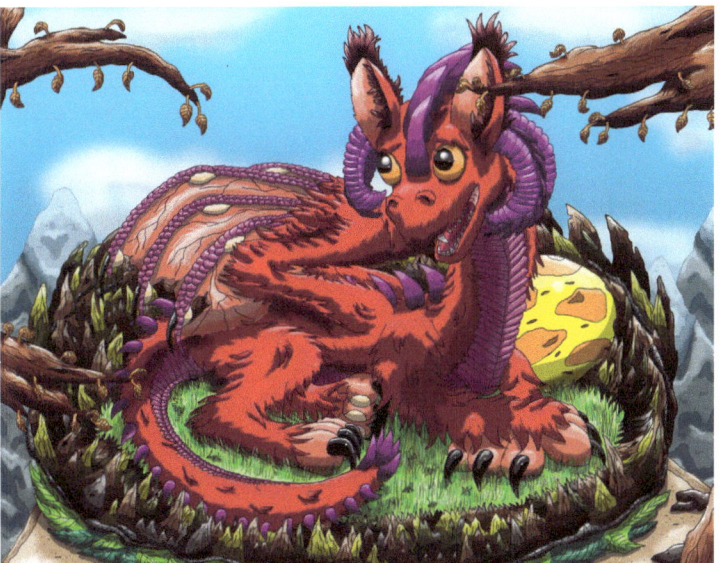
*Stranger the Baby Dragon - 2015*

www.ingramcontent.com/pod-product-compliance
Lightning Source LLC
Chambersburg PA
CBHW051026180526
45172CB00002B/483